# *A* GUIDE *TO* HISTORIC
## New Haven
### CONNECTICUT

# A GUIDE TO HISTORIC
# New Haven
## CONNECTICUT

COLIN M. CAPLAN

THE
History
PRESS

Published by The History Press
Charleston, SC 29403
www.historypress.net

*Cover image:* 52 Hillhouse Avenue. *Photograph by Colin M. Caplan*

First published 2007

Manufactured in the United States

ISBN 978.1.59629.245.1

Library of Congress Cataloging-in-Publication Data

Caplan, Colin M.
A guide to historic New Haven, Connecticut / Colin M. Caplan.
p. cm.
Includes bibliographical references and index.
ISBN-13: 978-1-59629-245-1 (alk. paper)
1. New Haven (Conn.)--Tours. 2. Historic buildings--Connecticut--
New Haven--Guidebooks. 3. Historic sites--Connecticut--New Haven-
-Guidebooks. 4. Dwellings--Connecticut--New Haven--Guidebooks.
5. Streets--Connecticut--New Haven--Guidebooks. 6. Neighborhood--
Connecticut--New Haven--Guidebooks. 7. New Haven (Conn.)--Buildings,
structures, etc.--Guidebooks. 8. New Haven (Conn.)--History. 9. New Haven
(Conn.)--Biography. I. Title.
F104.N63C37 2007
917.46'80444--dc22
2007027884

# *Contents*

# Driving Tours

# *Acknowledgements*

I f not for the alignment of certain cosmic conditions, I am sure I would not have ever imagined finding myself pursuing a historical record of my birthplace. Other factors must have contributed to this task and allowed me to overlook the backaches and tedium associated with researching and writing such a work.

I want to give my foremost appreciation and credit to my family: my mother Francine, with all of your excitement and your full attention; my father Bob, with your total moral and technical support; my sister Amy, with your inspiring presence and pioneering ideas; Nico, Sophie and Julien; my grandparents, Harriet and Arthur, Grace and Irving; and Charlie. Every one of you encouraged and inspired me in the greatest way. To Cristina, who has made my life exciting and delicious, thank you for your humor, support and needed distractions. To my cat, Sheba, I owe the warmth of my lap, and a good remedy to shedding cat hair.

I thank my good friend Henry Dynia for renewing my appreciation of our city; Mike Hennessey, as my neighborhood cohort and author extraordinaire; and Frank Toro III, artist, attorney and dear friend. I would like to recognize those who have encouraged and nurtured my interests: Yoshi and Bun Lai; Bonnie Eletz; John Cavaliere; Thea Buxbaum; Geoff and Kathy Harris; Gabriel Da Silva; John and Gail Campagna; John Herzan; Anstress Farwell; Jim Paley; Joe Taylor; Jay Bright; Mike Eskridge; Kevin Hogan; Scott Ketaineck; Guru Dev Khalsa; Jen Lindley; Sara Francis; Jodie Barnhart; Beth Tinker; Matt and Erika Golia; Nan Bartow; Dan Antinozzi; Antonio Huggins; and Professor Elizabeth Gamard.

The root of my interest in New Haven—architecture and history— is owed to Elizabeth Mills Brown, whose book, *New Haven: A Guide to Architecture and Urban Design*, became my own urban fabric comic strip when I was thirteen years old.

For assisting me in my quest to find the truth, and a lot of it, I would particularly like to thank Francis Skelton of the New Haven Museum and Historical Society for her unyielding passion and care for history. Also at the museum I would like to thank Jim Campbell, Amy Trout and Bill Hosley for their assistance. Thanks to Eddie Camposano and Frank Gargiulo at the Building Department; the Hall of Records; the New Haven Free Public Library; Leah Glaser; David Barkin; Chris Wigren; and Deb Townsend.

# Introduction

T his book is meant to guide you through New Haven in the present day with a filter of historic data. The inspiration is *New Haven: A Guide to Architecture and Urban Design* by Elizabeth Mills Brown, probably the handiest local guidebook around, even though it is now fairly dated (1976). Although there is an attempt to emulate Brown's itineraries and layout, this book is really a separate and unique version.

Understanding New Haven is not necessarily an easy task. To some the city is an urban center, a college town, a party town or a brownfield site. To many the city is home, work, school; fascinating, pleasant, artsy, boring, hellish or even pathetic. There are so many places in New Haven, so close to each other, but so different in many aspects. The guided tours in this book will expose a lot of these complicated relationships. For example, within one city block one may find posh mini-estates with private school bumper stickers on the latest hybrid vehicle, while on the other end of the block there are bruised tenements with last week's garbage strewn about eroded front walks. On one side of the block hired landscapers are sterilizing and pruning, while on the other side of the block undesired all-terrain vehicles reap sandstorms and reach polluting decibel levels.

The city is economically and racially diverse, although it is visibly polarized by these factors. New Haven has the distinction of having some of the smartest and potentially most influential people in the world come through its universities, while also having one of the lowest median household incomes and highest poverty rates in the state. Where manufacturing was once the prime employer, most jobs now lie in the service industries that cater to Yale University, two large hospitals and the municipal government. There is a visible physical polarization, as Yale stabilizes the downtown and Prospect Hill areas with real estate control, campus infrastructure and security patrols, while areas just beyond—like Dwight, the Hill and Newhallville—are ruled by welfare-driven landlord/tenant housing and small pockets of resident homeowners.

This book attempts to educate the reader about the city's history through the inherent connectedness of each separate building, site, event and person. In many cases there are connections made within each tour based on neighborhood geography and growth patterns. In

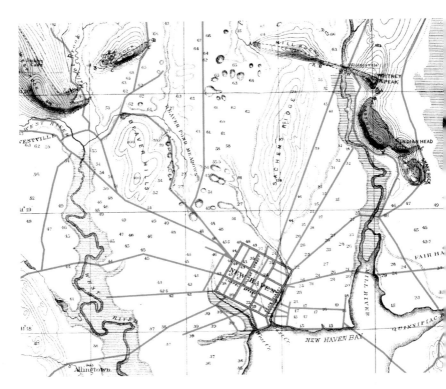

Map of the New Haven region from around 1800. *Compiled by Colin M. Caplan on a base map by James D. Dana.*

other cases, connections between entries may seem quite disconnected in chronology, scale and style. This may occur because the tours attempt to show buildings and sites that are either the best preserved architecture or the most culturally fascinating history. It is advisable that you familiarize yourself with a general historical outline of New Haven in tandem to using this guide.

TOURS
The self-guided tours in this book traverse all kinds of urban areas and conditions. There are twenty-seven tours total—eighteen walking tours and nine driving/biking tours. Each tour has a map that shows the route as a black line, beginning with number 1. Referenced buildings are shaded black and numbered, while referenced sites are simply numbered. Tours range in length and may take anywhere from forty minutes to three hours, depending on the tour, speed and method of travel.

Tours are named after the neighborhoods they cover. In some cases the names may be unfamiliar or repetitive, but rest assured that there is a logic behind their names. Please be aware that the driving tour routes may repeat parts of the walking tour routes. In some cases there may be a photograph for one of the walking tour entries that is located in the driving tour that traverses that same neighborhood.

## ENTRY IDENTIFICATION

The entries are all commonly noted in a uniform font. The titles begin with the tour letter, followed by the entry number (for example, A14). Next the present address is given, followed by the historic name, if applicable (for example, 121 Church Street, The Exchange Building). After that, the date of construction is given, followed by other dates that confirm additions, alterations or site moves (for example, 1901; circa 1923). If a date cannot be determined a "circa" before the date indicates an approximate date. The final information given is the architect, if known (for example, Frank Elmwood Brown).

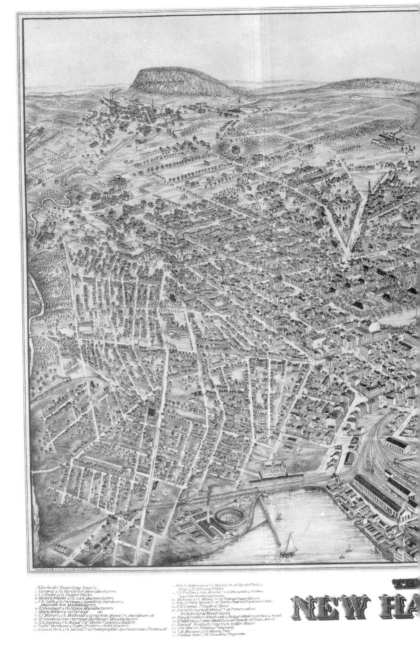

View of New Haven, Connecticut, 1879. *Drawn by Oakley Hoopes Bailey. Courtesy of Joseph Taylor.*

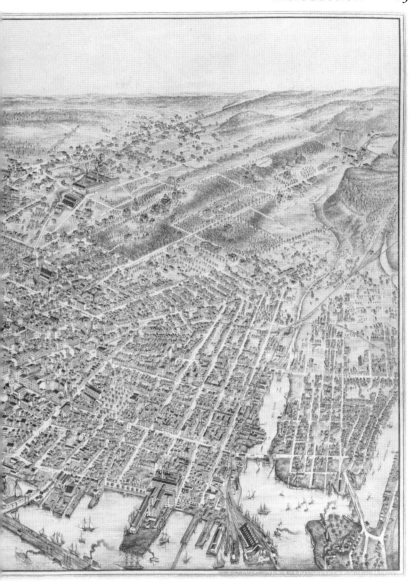

*ITY OF*
**EN, CONN.**
*9.*

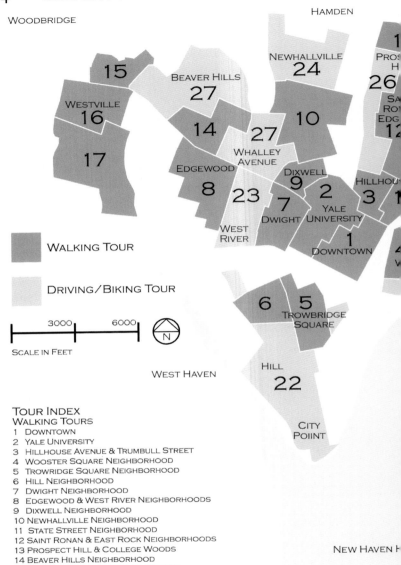

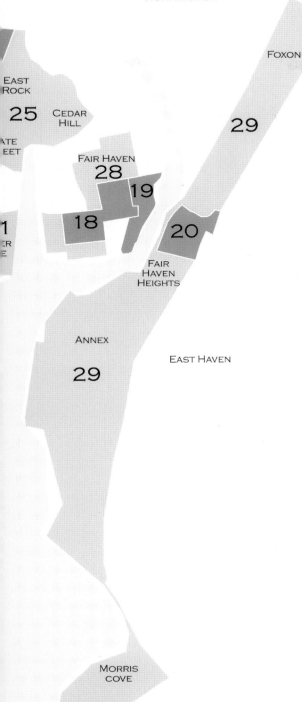

NORTH HAVEN

FOXON

EAST
ROCK

25    CEDAR
HILL

ATE
EET

FAIR HAVEN
28
19

1
ER
E

18    20

FAIR
HAVEN
HEIGHTS

ANNEX

EAST HAVEN

29

MORRIS
COVE

Master tour map.
*Compiled by*
*Colin M. Caplan.*

Walking Tours

# Tour A.

# *Downtown*

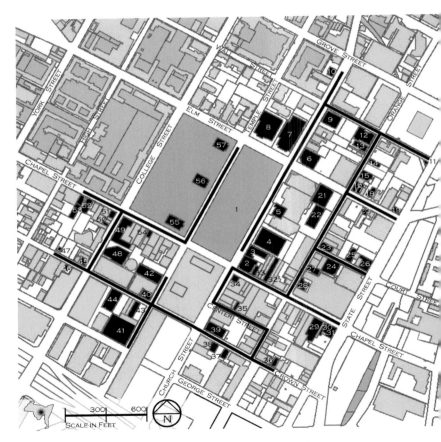

Downtown walking tour map. *Compiled by Colin M. Caplan.*

## A1. THE GREEN

The center of the historic planned city and the original market square, the New Haven Green was the site of the first meetinghouse and jail in 1640 and the first schoolhouse in 1645, which was built by the Puritans from England. The first Puritan graveyard began in 1638, located on the western rise behind Center Church. After more than five thousand people were laid to rest here, the last burial took place in 1812 and the gravestones were moved to the Grove Street Cemetery beginning in 1796. Improvements included the elm trees planted in 1790 by the civic leader James Hillhouse, filling the swamp on the eastern side in 1820 and installing an iron fence in 1846.

## A2. 121 CHURCH STREET, THE EXCHANGE BUILDING, 1832

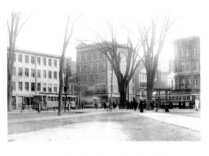

This was one of the first buildings built solely for commercial purposes. The design incorporates simple Greek Revival-style details with a repetitive window pattern taken from industrial building design. The cupola and first-story granite columns reflect the original design and replaced later alterations.

The corner of Church and Chapel Streets from the Green, 1905. *Courtesy of Colin M. Caplan.*

## A3. 129–31 CHURCH STREET, SECOND NATIONAL BANK OF NEW HAVEN BUILDING, 1912–13: STARRETT & VAN VLECK, NEW YORK

Considered a skyscraper when built, this bank constructed its fourth home after the post office and courthouse replaced its former home next door.

## A4. 145 CHURCH STREET, POST OFFICE AND FEDERAL DISTRICT COURT, 1913: JAMES GAMBLE ROGERS, NEW YORK

Neoclassical design gives dignity and order to a busy corner and provides a governing presence on the Green. The court has been the site of numerous judgments against corrupt local politicians.

145 Church Street, post office and federal district court, March 2007. *Photograph by Colin M. Caplan.*

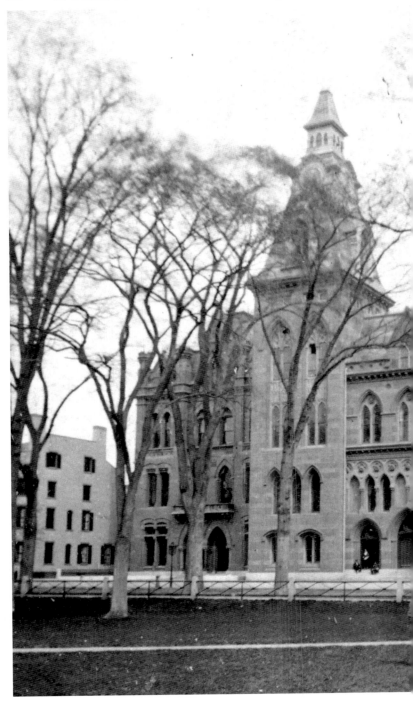

165 Church Street, City Hall, circa 1875. *Photograph by Joseph K. Bundy. Courtesy of Colin M. Caplan.*

### A5. 165 CHURCH STREET, CITY HALL, 1861: HENRY AUSTIN AND DAVID R. BROWN

City Hall is a striking Victorian Gothic-style public building that inspired designs in the city for the next fifty years. Only the front portion of the old City Hall remains, while the rear and north wings are recent additions.

### A6. 205 CHURCH STREET, UNION & NEW HAVEN TRUST CO., 1927–28: CROSS & CROSS, NEW YORK

A Colonial Revival-style office tower for the parishioners of the banking world, this building marks the corner with an angled entrance and tower. Its design reflects the church architecture on the Green.

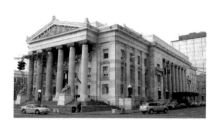

121 Elm Street, New Haven County Courthouse, March 2007. *Photograph by Colin M. Caplan.*

### A7. 121 ELM STREET, NEW HAVEN COUNTY COURTHOUSE, 1913–14: WILLIAM H. ALLEN AND RICHARD WILLIAMS

Straight out of Piranesi's dream world, the courthouse seems fit for a king, or at least a Parisian museum. The sculpture in front was designed by J. Massey Rhind.

### A8. 133 ELM STREET, NEW HAVEN FREE PUBLIC LIBRARY, 1908–10: CASS GILBERT, NEW YORK

Designed by one of the county's most prominent architects in the early twentieth century, the Colonial Revival-style design was the winner of a design competition.

### A9. 227 CHURCH STREET, SOUTHERN NEW ENGLAND TELEPHONE CO., 1937: ROY W. FOOTE AND DOUGLAS ORR

New Haven's finest Art Deco architecture and a major piece of the city's skyline, the Telephone Building was a bold wakeup call at the end of the Depression. The design stresses the building's verticality; it was the tallest building in the city at the time of its construction.

### A10. 250 CHURCH STREET, PRESIDENT THEODORE DWIGHT WOOLSEY HOUSE, 1841; 1901: R. CLIPSTON STURGIS, NEW YORK

Originally a simple five-bay Greek Revival-style house, a major face-lift added the northern section and unified the façade with Federal-style details. After being home to Woolsey, one of Yale's most prominent presidents, the house was remodeled for commercial use in 1935–36 by the university.

**A11. 556–66 State Street, William Button Building, 1856–59; 1908: Frank Elmwood Brown**

Mr. Button, a confectioner, built this triangular building between the street corner and the Farmington Canal Railroad. The canal line began construction in 1825–35 on an old creek bed and served to bypass Hartford's trade route. In 1908, the façade was remodeled for George Lucas's saloon.

227 Church Street, Southern New England Telephone Company, March 2007. *Photograph by Colin M. Caplan.*

**A12. 292 Orange Street, Congregation Church of the Redeemer, 1870: David R. Brown**

The brick and sandstone pattern of this Gothic Revival–style church is reminiscent of City Hall. In 1916, Trinity Lutheran moved into the church.

**A13. 281–84 Orange Street, Kensington Flat, 1878**

This Romanesque Revival–style building is considered New Haven's first apartment house and was inspired by the Queen Anne apartments being built in London's Kensington neighborhood at that time.

**A14. 275 Orange Street, William Pinto House, circa 1805: David Hoadley**

This Federal-style house was built by renowned builder David Hoadley for William Pinto, son of the city's first Jewish resident. Pinto's family renounced Judaism and became Whigs. Pinto graduated from Yale and defended the city during the British invasion of 1779. It is believed that inventor Eli Whitney spent his last night here.

**A15. 261–67 Orange Street, 1880**

Behind some additions is a once-elegant Victorian row, complete with mansard roof and decorative brick work. Rows like these were built during the second half of the nineteenth century as the higher land values created a need for denser units.

**A16. 51–53 Elm Street, Harlan P. Hubbard Building, circa 1879**

This Italianate-style commercial block was built for Harlan P. Hubbard, who ran an international newspaper advertising agent firm.

## A17. 47 ELM STREET, IMPERIAL GRANUM BUILDING, 1877: RUFUS G. RUSSELL

This is the only cast-iron building left in the city. The Imperial Granum Company processed medicinal foods.

## A18. 35 ELM STREET, JOHN COOK HOUSE, 1805–06

This Federal-style house was built for Mr. Cook, a tailor and merchant. In 1814, Captain James Goodrich, later president of the Canal Line Railroad, purchased the house and may have hired David

47 and 51–53 Elm Street, March 2007. *Photograph by Colin M. Caplan.*

Hoadley to construct an arched ballroom on the third floor. The house is considered the earliest stucco building in New Haven.

## A19. 506–08 STATE STREET, ALFRED A. KELLOGG BUILDING, 1878

This Victorian corner block was once part of a row of similar design built in the same year along State Street. Alfred Kellogg ran a sportsman's supply store here that sold locks, guns and fishing tackle.

## A20. 32 ELM STREET, TIMOTHY BISHOP HOUSE, CIRCA 1815

This house is the best extant example of Federal-style architecture in New Haven. The front yard was lost after the street was lowered in the late 1800s. A ballroom on the third floor dating from the 1930s was designed to match the John Cook House across the street.

## A21. 80 ELM STREET, ST. THOMAS CHURCH, 1848; 1948: ROY W. FOOTE

32 Elm Street, Timothy Bishop House, March 2007. *Photograph by Colin M. Caplan.*

The mask of an Art Modern building designed for the First Federal Savings & Loan Association of New Haven in 1948 covers the remains of a Gothic Revival–style Episcopal church dating from a century before. The nave of the church can still be seen behind the two-story addition.

**A22. 200 ORANGE STREET HALL OF RECORDS, 1929: EGERTON SWARTWOUT, NEW YORK**
A grand civic building with compact and noble proportions, the limestone blocks and three-story engaged Doric pilasters are Beaux Arts style.

**A23. 181–91 ORANGE STREET, THE TEMPLE BUILDING, 1844–45; 1906: BROWN & VON BEREN**
This building was built as a Greek Temple-style Masonic meeting hall with a two-story sanctuary where social clubs long held their activities. In 1888, it was called Turn Hall and then the Steinert Building in 1905 after Morris Steinert purchased the property and added the three-story addition to the front.

**A24. 116–26 COURT STREET, SOUTHERN NEW ENGLAND TELEPHONE COMPANY BUILDING, 1916: LEONI ROBINSON; 1926: ROY W. FOOTE**
This building had no street face until 1926, when the front portions and two additional stories were added. The Southern New England Telephone Co. began as the District Telephone Co. of New Haven and it was responsible for the world's first commercial telephone exchange in 1878.

**A25. 109–13 COURT STREET, MORY'S SALOON, CIRCA 1845; 1919: NORTON & TOWNSEND**
The second home to the famous Mory's poured its first of many ales for Yale students here in the early 1860s when Frank and Jane Moriarty moved their bar and hotel here. After Mory's moved to Temple Street in 1876, the building became the Hotel Brunswick and an addition was built on the front in 1919, which was called the Wells.

**A26. 410–18 STATE STREET, JAMES E. ENGLISH BUILDING, 1864–68**
This Italianate-style commercial block was built by Mr. English, who at the time was the largest property owner and one of the leading citizens in the city. Mr. English became governor of Connecticut from 1867 to 1871 and a U.S. senator from 1875 to 1877.

**A27. 157–61 ORANGE STREET, PITKIN BUILDING, CIRCA 1855; 1908–09: ALLEN & WILLIAMS**
This building was built near the corner of Pitkin Street, one of the oldest privately owned roads in the country. Originally the building was a double townhouse, but a Mission-style front was added in 1908 to accommodate commercial uses.

**A28. 131–45 ORANGE STREET, INSTITUTE BUILDING, 1855**
Built for the Young Men's Institute. New Haven's first high school, Hillhouse, began on the fourth floor of this building in 1859. In the late 1880s, the *New Haven Palladium* newspaper was housed here. This is by far the city's best example of an Italianate-style

commercial building, built by Robert Treat Merwin.

### A29. 760–66 Chapel Street, Monson Building, 1891; 1904; 1909: Leoni W. Robinson

The Charles Munson Co. dry goods store operated out of this Renaissance Revival-style building. Its electric elevator is one of the oldest existing in the city. Alterations were made in 1904 and an addition was added to the rear in 1909.

### A30. 754 Chapel Street, John E. Bassett & Co., 1828

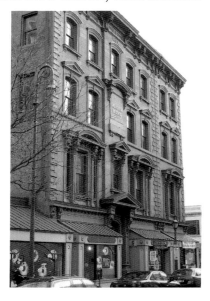

131–45 Orange Street, Institute Building, March 2007. *Photograph by Colin M. Caplan.*

This is the oldest extant commercial building downtown and it was built for Samuel Hughes, who operated a hardware store. In 1855, it became the John E. Bassett & Co. hardware store, which had its roots in a store started in 1784.

### A31. 742–50 Chapel Street, Street Building, 1832; 1921: Roy W. Foote

Elihu Atwater built this brick edifice, one of the city's earliest solely commercial buildings. It was owned by the Street family, who ran a hardware store here. The first two floors on the Chapel Street façade were remodeled in 1921.

### A32. 837–39 Chapel Street, English Building, 1882: Brown & Stilson; 1898: Leoni W. Robinson

This building was originally lavishly ornamented in the Victorian style, but after a fire a new front was installed in 1898 for Henry F. English, a lawyer and real estate broker.

### A33. 851–53 Chapel Street, Austin Building, 1861

This Italianate-style building was home to the Gardner Morse Co., a real estate and insurance company.

### A34. 866–78 Chapel Street, Cutler Corner, 1860: Henry Austin; 1909: Charles E. Joy

This commercial block was constructed one year after the Richard Cutler House burned on the same site. After the National Bank Act

35–37 Center Street, Security Insurance Building, March 2007. *Photograph by Colin M. Caplan.*

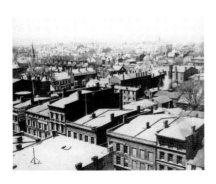

View looking east of the Ninth Square from the Chapel Street railroad depot, circa 1865. *Courtesy of the New Haven Free Public Library.*

was passed in 1863, the First National Bank of New Haven made this building its home. The top floor was added in 1909.

### A35. 35–37 CENTER STREET, SECURITY INSURANCE BUILDING, 1887; 1947

Hidden behind renovations, this is one of the best examples of a Richardson Romanesque–style building left in the city. The Security Insurance Company began in 1841 and erected their first building here. In 1947, the first two floors were altered in the International style.

### A36. 47 CROWN STREET, FIREHOUSE 12, 1905: BROWN & VON BEREN

This former firehouse retains much of its original flair and is still a recognizable icon, despite alterations. The building is embellished with classical ornamentation, but its materials and scale fit into the downtown fabric.

### A37. 100 CROWN STREET, NEW HAVEN WATER CO., 1903: LEONI ROBINSON

Built as the headquarters to the region's water utility, this building is designed in the Renaissance Revival style. The water company began as a private entity in 1849 and became public in 1980.

### A38. 116–20 CROWN STREET, MAYLINGER BLOCK, 1894

This Romanesque Revival and Queen Anne–style mixed-use building was built for Frank W. Maylinger, a partner in Maylinger & Hugo, the sausage company that was located on the first floor. In 1911, the building was converted to bachelor apartments and was called the National Hotel.

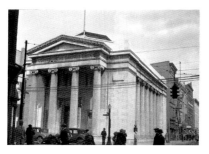

45 Church Street, Connecticut Savings Bank, circa 1935. *Photograph by the United Advertising Corporation. Courtesy of Colin M. Caplan.*

**A39. 45 Church Street, Connecticut Savings Bank, 1906: Gordon, Tracy & Swartwout**
This is the city's best example of a Greek Temple banking building. The Connecticut Savings Bank opened in 1857 as the second savings bank in the city.

**A40. 124–32 Temple Street, United Illuminating Co. Building, 1909–10: Foote & Townsend**
This Venetian palazzo-style building is a downtown gem. The third story and north wing were added in 1914. The United Illuminating Co. began in 1899 when the Bridgeport and New Haven Electric Companies merged.

**A41. 80 Temple Street, United Illuminating Co. Building, 1930: Roy W. Foote**
This was the utility's second home designed in the Colonial Revival style, mimicking the churches on the Green.

**A42. 148–56 Temple Street, Liberty Building, 1902–03: Brown & Von Beren**
Designed in the Beaux Arts style, this building was constructed for the Young Men's Christian Association as a residential hotel. The YMCA stayed here until larger facilities were constructed in 1924 at 44 Howe Street (see G19).

**A43. 196–200 Crown Street, P.J. Kelly Furniture Co., 1914 and 1919: William H. Allen**
After this building was built in 1914 as an automobile repair shop, Irish immigrant Peter J. Kelly added four floors and moved his furniture store here in 1919. Adorning the classically designed marble façade is a row of eagle gargoyles.

**A44. 216 Crown Street, Elks Lodge Building, 1929: Alfred W. Boylen**
This private hall and club was designed reflecting both Gothic Revival and Art Moderne styles. In the 1950s, the meeting hall became a motion picture theater.

**A45. 222 College Street, Ira Atwater House, circa 1817**
This Federal-style house was built by Atwater, whose family was the city's leading builders for about a century. This house was altered for commercial use around 1920.

**A46. 250 Crown Street, circa 1845**
One of the few remaining mid-nineteenth-century townhouses left in the downtown area, this Greek Revival-style house is remarkably unchanged since it was built. Houses like this used to dot every corner and block of the central city.

**A47. 261–63 Crown Street, Louis' Lunch, 1895; 1975**
This is the site of the world's first hamburger, maybe; or at least that is their claim to fame. This minute restaurant was even smaller when it was added to a larger building on George Street for Louis Lassen. The restaurant was moved to its present site in 1975 to make way for the Temple Medical Center.

**A48. 247 College Street, Shubert Theater, 1914: Albert Swazey, New York**
The Shubert brothers built this theater two years after the Shubert Theater in New York. With a seating capacity of 1,820, this Shubert Theater was the largest in the state at the time of construction. Some of the outstanding premieres include *Robinson Crusoe Jr.*, *The King and I*, *The Sound of Music* and *A Streetcar Named Desire*. Some of the stars who gained acclaim here were Humphrey Bogart, Katherine Hepburn, Jimmy Stewart, Robert Redford, Shirley MacLaine, Jane Fonda, Sydney Poitier, James Earl Jones, Liza Minelli and John Travolta. The theater closed in 1976, but reopened in 1983 after renovations and construction of a new façade.

**A49. 266 College Street, circa 1865; 1915: Charles F. Townsend**
The ornate terra cotta façade of this building provided more room for the commercial activity of the early twentieth century. Behind the façade lie the remnants of a much earlier row house from about 1865.

**A50. 265 College Street, Taft Hotel, 1911–12: Frank M. Andrews, New York**
The city's tallest building when built, the Taft Hotel catered to visitors from around the world for sixty years, until it closed in 1973. The hotel was built on the site of earlier hotels and taverns, one of which George Washington stayed in on July 2, 1775.

**A51. 1000–06 Chapel Street, Townsend Block, circa 1832**
One of New Haven's first solely commercial buildings, the Townsend Block was designed in Greek Revival style. The building was built by the Townsend family, who were shipping merchants.

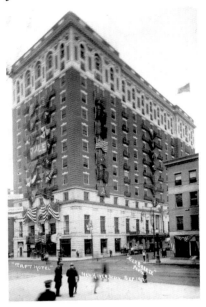

265 College Street, Taft Hotel, September 1912. *Courtesy of Joseph Taylor.*

**A52. 1032 Chapel Street, Union League Club, 1860: Henry Austin; 1902: Richard Williams**
In the rear of this property is the Italianate-style house built for Gaius Fenn Warner. Warner was the head of G.F. Warner & Co., malleable iron manufacturers. In 1874, Peter Carll moved here and built a two-thousand-seat opera theater in the back of the house in 1880; this was later called the Hyperion Theater. In 1902, the Union League Club built the present front Beaux Arts–style section.

**A53. 1042–44 Chapel Street, Warner Hall, 1892: Rufus G. Russell**
This Romanesque Revival–style building was built by Henry A .Warner as a private dormitory for Yale University students. It was one of the first buildings designed as an apartment house in the city. Warner Hall was also one of Russell's last design projects.

**A54. 962–64 Chapel Street, Bohan-Landorf Building, circa 1790; 1915: Shape & Bready, New York**
The middle section of this building is the Elias Shipman House, a Federal-style brick house. Shipman was a Long Wharf shipping merchant and president of the New Haven Insurance Co. In 1915, the Bohan-Landorf Co., furriers operated by William E. Bohan and Henry A. Landorf, added the Beaux Arts–style façade.

**A55. 240 Temple Street, Trinity Church, 1813–14: Ithiel Town; 1870: E.T. Littell, New York; 1884: Henry Congdon, New York; 1906: Leoni Robinson**
A remarkably original design, this church is one of the first three Gothic Revival–style churches in the country. Trinity dates back to 1752, when a group of Congregationalists started the First Church of England. In 1870, the original wooden spire was replaced with stone and a chancel was added in 1884. A number of alterations occurred inside, including the transformation to the Gothic style in 1906.

**A56. 250 TEMPLE STREET, FIRST CONGREGATIONAL CHURCH, 1812–15: ASHER BENJAMIN, BOSTON; 1842: HENRY AUSTIN**

Considered one of the most ceremonial Federal-era churches in the country, First Congregational Church, usually called Center Church, was designed after James Gibbs's St. Martin-in-the-Fields in London. Alterations include Henry Austin's interior remodeling in 1842. This congregation was the first in New Haven, beginning as the First Ecclesiastical Society in 1641. The building was constructed over the old graveyard and below the church still lie some of the stones, called the Crypt.

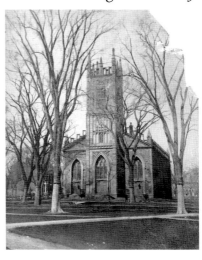

240 Temple Street, Trinity Church, circa 1865. *Courtesy of the New Haven Free Public Library.*

**A57. 270 TEMPLE STREET, UNITED CHURCH, 1812–15: EBENEZER JOHNSON**

Referred to as the North Church, this congregation began with the joining of the White Haven and Fair Haven Churches. In 1884, they combined with the Third

Temple Street at the Green, circa 1895. *Courtesy of Colin M. Caplan.*

Church. The Federal design is based on a design of All Saints in Southampton, England, by the German C.L. Stieglitz and was built by David Hoadley. In 1849, the interior was completely remodeled.

# Tour B.

# *Yale University*

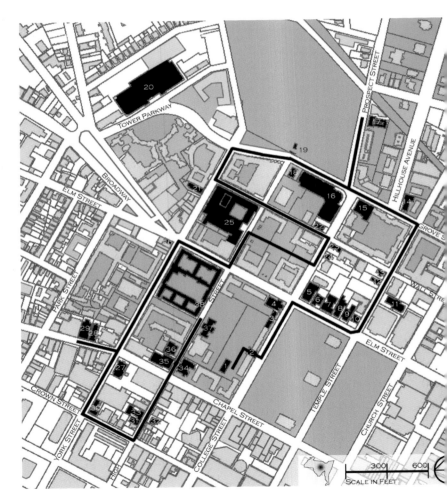

Yale walking tour map. *Compiled by Colin M. Caplan.*

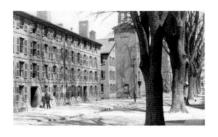

Connecticut Hall, 1895. *Courtesy of Colin M. Caplan.*

## B1. CONNECTICUT HALL, 1750–52; 1905: GOSVENOR ATTERBURY, NEW YORK

This building is based on Harvard's Massachusetts Hall. Yale College gained the funds to build this dormitory from the sale of a captured French frigate. Yale president Thomas Clap organized the labor for its construction and hired master masons Francis Letort from Philadelphia and Thomas Bills from New York. Clap's plan involved the construction of a row of buildings, called the Brick Row, which were built over the next eighty-five years. In the mid-nineteenth century, the original gambrel roof was replaced, and then rebuilt again in 1905.

## B2. COLLEGE STREET, PHELPS HALL, 1896: CHARLES C. HAIGHT, NEW YORK

This Tudor-style gateway was the last building constructed creating a street wall along the Green on the old campus. Phelps forms the central entrance to the campus from the city through an arched walkway.

## B3. COLLEGE STREET, FARNAM HALL, 1869–70: RUSSELL STURGIS, NEW YORK

Farnam was the first dormitory built along the street that became Yale's new face along the Green. It was designed in the Victorian Gothic style, which had been popularized by City Hall across the Green.

## B4. ELM STREET, BATTELL CHAPEL, 1874: RUSSELL STURGIS, NEW YORK

This Victorian Gothic–style chapel fits in with the surrounding dormitories that were built during the same period. Battell replaced the old chapel, which was part of Brick Row.

## B5. ELM STREET, FIRST METHODIST CHURCH, 1849: HENRY AUSTIN; 1904: CHARLES C. HAIGHT, NEW YORK

Originally designed as a late Federal-style church, there were a number of alterations made to this building during the mid- to late nineteenth century. After a fire, the church was again altered to a Federal Revival style with a new portico and steeple in 1904.

## B6. 175 ELM STREET, NICHOLAS CALLAHAN HOUSE, 1762 OR 1776; 1911: EDWARD V. MEEKS

The original date of this Colonial-style house is not determined. Callahan was a Loyalist during the Revolutionary War and the house was called the Tory Tavern. In 1910, it was purchased by the Elihu

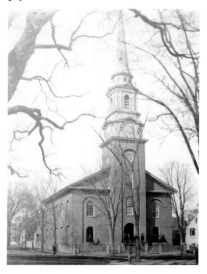

Elm Street, First Methodist Church, circa 1864. *Courtesy of the New Haven Free Public Library.*

Club senior society, and one year later it was remodeled.

**B7. 165 ELM STREET, HENDRIE HALL, 1894; 1900: CADY, BERG & SEE, NEW YORK**
Built as the Yale Law School, Hendrie Hall was planned to be part of a row of similar structures along Elm Street. It was designed in the style of a Venetian palazzo.

**B8. 155 ELM STREET, JONATHAN MIX HOUSE, 1799; 1902: R. CLIPSTON STURGIS, BOSTON**
This Federal-era house is a good example of the kind of frame dwellings that were built in New Haven during that time period. Eli Whitney Blake, inventor of the rock crusher, lived here in the 1830s. In 1901, the Graduate Club purchased the property and built the addition at the rear.

**B9. 149 ELM STREET, JOHN PIERPONT HOUSE, 1767; 1900: DELANO & ALDRICH, NEW YORK; 1929: J. FREDERICK KELLY**
Pierpont was a descendant of one of the founders of Yale College and the house was used by the British as a headquarters and hospital when they seized the city in 1779. In 1900, the rear additions were built to match a Federal-style house nearby, and in 1929 Yale remodeled the house back to a variation of its original design.

**B10. 143 ELM STREET, RALPH INGERSOLL HOUSE, 1829: TOWN & DAVIS; 1919: DELANO & ALDRICH**
This Greek Revival–style house was built by Nahum Hayward for Mr. Ingersoll, a lawyer, congressman and minister to Russia. Interestingly, during the house's construction Ingersoll wrote a letter to the architects revealing that the specifications were missing. After it was purchased by Yale University in 1919, the house was restored.

**B11. 311 TEMPLE STREET, EZEKIEL HAYES TROWBRIDGE HOUSE, 1852: SIDNEY MASON STONE; CIRCA 1910**
Trowbridge was a West Indian shipping merchant and local banker. The Renaissance Revival style was considered quite extravagant at the time it was built. In 1910, the house was given to Center Church, which added the rear addition and used it as a parish house.

**B12. 320 TEMPLE STREET, REVEREND JUDIDIAH MORSE HOUSE, CIRCA 1820**

Morse is considered the father of American geography, and he authored the first academic geography textbook in the country in 1784. The French Second Empire–style house, originally designed in the Federal style, was altered around 1870.

**B13. 328 TEMPLE STREET AND 66 WALL STREET, JOHN HART LYNDE HOUSE, 1806; 1920: J. FREDERICK KELLY**

Lynde, a lawyer and county clerk, had this house built for himself after he graduated from Yale College. A brick addition was built along Wall Street around 1850 and the house was remodeled in 1920.

**B14. 131 GROVE STREET, CLOISTER HALL, 1887: H. EDWARDS FICKEN, NEW YORK; 1915: METCALF & BALLANTYNE, NEW YORK**

Elements of Romanesque, Tudor and Chateauesque styles combine to create a unique design in this building. The hall was built as a fraternal clubhouse. The rear half of the building was added in 1915.

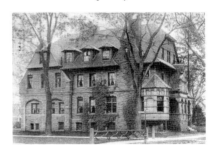

131 Grove Street, Cloister Hall, circa 1905. *Courtesy of Colin M. Caplan.*

**B15. 509 COLLEGE STREET, BYERS HALL, 1902–03: HISS & WEEKS, NEW YORK**

Designed in the Beaux Arts style after the Petit Trianon at Versailles, France, efforts were made for the building to match the Bicentennial Buildings across College Street. The hall was originally used as a social and religious center for Sheffield Scientific School.

**B16. COLLEGE STREET, WOOLSEY HALL, COMMONS AND MEMORIAL HALL, 1901–02: CARRÈRE & HASTINGS, NEW YORK**

These buildings were built in commemoration of Yale's two hundredth birthday. Woolsey Hall holds a 2,700-seat auditorium and the Newberry Memorial Organ, one of the largest organs in the world.

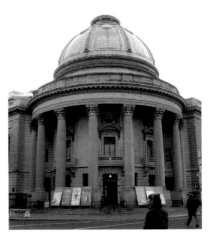

College Street, Woolsey Hall, March 2007. *Photograph by Colin M. Caplan.*

The Commons holds a large dining room and Memorial Hall is the domed connection and entryway.

**B17. Prospect Street, Sheffield Scientific School, 1894: Cady, Berg & See, New York**
This Romanesque Revival-style building housed a chemistry laboratory. It was once part of a row of science-related buildings called Sheffield Row.

**B18. 214 Grove Street, Book and Snake Society, 1900: R.H. Robertson, New York; 1915: Metcalfe & Ballantyne**
Founded as Sigma Delta Chi, this marble block building is designed after a Greek temple. The fraternity was converted to a senior society in 1933.

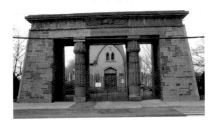

227 Grove Street, Grove Street Cemetery Gate, March 2007. *Photograph by Colin M. Caplan.*

**B19. 227 Grove Street, Grove Street Cemetery, 1796; 1814; 1845: Henry Austin; 1872**
On land selected by James Hillhouse, a leading townsman, this cemetery replaced the city's original burying ground on the Green. It is considered the first cemetery in this country to be designed around family plots. The perimeter was expanded in 1814, the Egyptian Revival-style gate built in 1845, the wall built in 1845-48 and the chapel built in 1872.

**B20. 70 Tower Parkway, Payne Whitney Gymnasium, 1930-32: John Russell Pope and Otto Eggers, New York**
This monolithic Gothic Revival-style building was inspired by Sir Giles Gilbert Scott's Liverpool Cathedral in England. The tower's verticality is accentuated and the lower wings seem heavy and planted.

**B21. 306 York Street, Mory's, 1800; 1912**
This Federal-style house was the third home of Mory's Tavern in 1876, which was begun by Frank and Jane Moriarty in 1861. This building was moved from the corner of Temple and Center Streets in 1912 to make way for a larger building.

**B22. 484 College Street, Scroll and Key, 1869: Richard Morris Hunt, New York**
Colorful stripes of stone adorn this Moorish tomb-style secret society. This is the only building left in the city that was designed by Hunt.

**B23. 469 College Street, York Hall, 1897: Grosvenor Atterbury, New York**
This Venetian palazzo–style building was constructed for the Chi Phi fraternity. In 1935, it was purchased by Yale for use as a dormitory and then renamed Stoeckel Hall.

**B24. 459 College Street, Leverett Griswold House, circa 1810**
An elegant example of a Federal-style house; the Elizabethan club, a literary

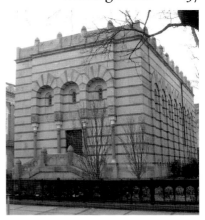

484 College Street, Scroll and Key, March 2007. *Photograph by Colin M. Caplan.*

society, purchased this house in 1911. Cole Porter, songwriter and Yale graduate, mentions the club in one of his verses.

**B25. 120 High Street, Sterling Memorial Library, 1927–30: James Gamble Rogers, New York**
The sixteen-story tower of books highlights the importance and growth of the university. The building is designed in the Gothic style and is modeled after a cathedral. The rooftop carries a miniature model of the Yale campus from about 1930.

**B26. 266–68 York Street, Langrock Building, 1927: Jacob Weinstein**
Yale's influence on the designs of the surrounding area's buildings can be seen here. Weinstein, a local architect, was required to let Yale's favorite New York designer, James Gamble Rogers, perform a design review. The Tudor-style building was approved and became home to Langrock Fine Clothes.

**B27. 1120 Chapel Street, Calvary Baptist Church, 1871: Rufus G. Russell**
This Victorian brick and stone church once marked this corner with a tall spire. It was removed in 1966, as is customary when a church is sold to a secular entity. In this case the new tenant was the Yale Repertory Theater.

**B28. 1145 Chapel Street, El Dorado Apartments, 1922: Brown & Von Beren**
With over forty units, this apartment building was considered an efficient design. It was designed in a so-called California style, marked by the large projecting cornice.

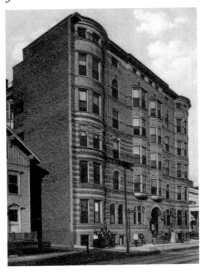

1151 Chapel Street, Hotel Majestic, circa 1905. *Courtesy of Colin M. Caplan.*

**B29. 1151 Chapel Street, Hotel Majestic, 1894: Foote & Townsend.**
Colorful brick and stone stripes along with full-height bay windows make a lively design for this Victorian hotel building. It was built for John and William Gay, but by 1898 Alex Duncan changed its name to Duncan Hall, a family hotel.

**B30. 313–19 Crown Street, Ms. E. Turner Block, 1879**
This pair of French Second Empire–style row houses is an excellent example of urban dwellings constructed in New Haven in the late nineteenth century.

**B31. 28–30 High Street, Abe Abelson Building, 1922: Jacob Weinstein**
Designed in a Georgian Revival style, this building housed apartments for the Yale community. Abelson developed and built the property.

**B32. 31–33 High Street, Frederick W. Northrop House, circa 1865**
This Italian Villa–style house was built for Mr. Northrop, the publisher of the *New Englander* magazine, in the mid-1850s.

**B33. 32 High Street, Cambridge Arms, 1925: Lester J.A. Julianelle**
Inspired by the Gothic designs being built at Yale, this substantial Jacobethan-style apartment building was meant to reflect the college's elegance and intellectualism.

**B34. 1023 Chapel Street, Street Hall, 1864: Peter B. Wright, New York; 1911: John Ferguson Weir and Leoni Robinson**
Built for the Yale School of Fine Arts, the first of its kind in the country, Street Hall is considered one of the first High Victorian Gothic–style buildings in the country. The northwest corner was added in 1911.

**B35. Chapel Street, Yale University Art Gallery, 1927: Egerton Swartwout, New York**
The old Yale Art Gallery, designed in a Tuscan Romanesque style, bridges High Street and connects with Street Hall. The bridge actually houses faculty offices.

**B36. 64 High Street, Skull and Bones, 1856; 1882; 1902–03**
Yale's first secret society included in its roster numerous presidents, politicians and other elites. The original building started out as only the left wing, designed like a Greek temple. In 1882, a rear addition was added and then in 1902–03 the right wing was added, mimicking the original section.

**B37. 67 High Street, Library, 1842: Henry Austin; 1931: Charles Z. Klauder**
This is Yale's first Gothic-style building and now the university's second oldest building. In 1931, the interior was remodeled into a more Gothic style and the building became Dwight Hall chapel.

**B38. 74 High Street, Harkness Memorial Tower, 1917: James Gamble Rogers, New York**
Probably Yale's most recognizable landmark, the design is an evolution of a Gothic tower. The airiness and quality of ornamental details by sculptor Lee Laurie make this one of the most exciting and beautiful towers in the city.

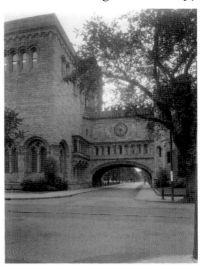

Chapel Street, Yale University Art Gallery, 1932. *Courtesy of the New Haven Free Public Library.*

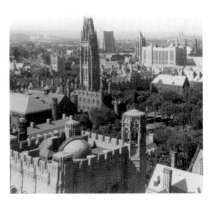

Skyline view of the Yale University campus from the Taft Hotel, circa 1935. *Photograph by the Keystone View Company. Courtesy of Colin M. Caplan.*

Tour C.

# Hillhouse Avenue and Trumbull Street

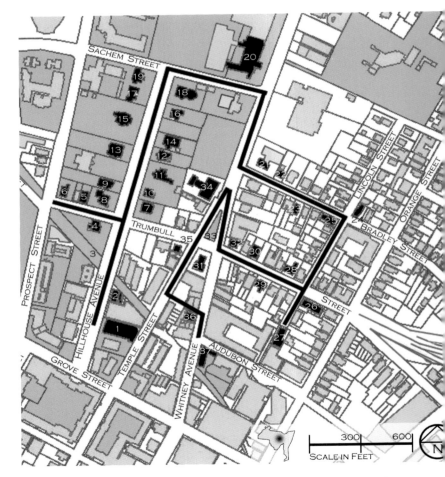

Hillhouse Avenue and Trumbull Street walking tour map. *Compiled by Colin M. Caplan.*

## C1. 5 HILLHOUSE AVENUE, ST. MARY'S CHURCH, 1870: JAMES MURPHY, PROVIDENCE

Founded in 1832 from the first Catholic parish in the city and the second in the state, this is one of the city's largest Gothic Revival–style churches. The Knights of Columbus started in the basement of the church in 1882 and were led by Father Michael J. McGivney. Although the spire was not originally built due to construction debt, it was recently added based on the original drawings.

## C2. 15 HILLHOUSE AVENUE, ALPHA DELTA PHI, 1894: J. CLEVELAND CADY, NEW YORK

Hillhouse Avenue and Trumbull Street, 1881. *Photograph by Pach. Courtesy of Colin M. Caplan.*

This fraternity house is an excellent example of the Richardson Romanesque style.

## C3. FARMINGTON CANAL, 1825–35

The rivalry with Hartford as a commercial and agricultural trading center led to the construction of this canal line that created a northward water route that bypassed the Connecticut River. By 1847, the canal was replaced by a rail line, which existed until 1987. This section of the canal bed was formed from a stream bed that emptied into the harbor.

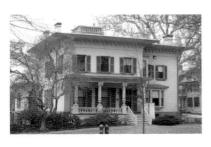

24 Hillhouse Avenue, James Dwight Dana House, March 2007. *Photograph by Colin M. Caplan.*

## C4. 24 HILLHOUSE AVENUE, JAMES DWIGHT DANA HOUSE, 1849: HENRY AUSTIN

This is a unique Italian Villa–style house with ornamentation influenced from India. Mr. Dana was an esteemed mineralogist, Yale professor and prolific author of scientific manuscripts.

## C5. 87 TRUMBULL STREET, BENJAMIN SILLIMAN HOUSE, CIRCA 1807; 1871

This Federal-era house was built by James Hillhouse and originally stood around the corner on Hillhouse Avenue. Professor Silliman was a highly regarded chemist and geologist. The house was originally a frame-structure rock-filled stucco, but in 1871 the masonry was removed and half of the frame was reassembled here.

## C6. 91 TRUMBULL STREET, WOLF'S HEAD, 1884: McKIM, MEAD & WHITE, NEW YORK

This Yale senior society building was designed by an architectural firm mentored by H.H. Richardson. This brownstone building was designed in the Richardson Romanesque style.

## C7. 27 HILLHOUSE AVENUE, REVEREND GEORGE PARK FISHER HOUSE, 1865

This Italian Villa-style house was built for Mr. Fisher, a reverend and professor at Yale Divinity School.

## C8. 28 HILLHOUSE AVENUE, CHARLES H. FARNAM HOUSE, 1884: J. CLEVELAND CADY OR RUSSELL STURGIS, NEW YORK; 1898: LEONI W. ROBINSON

This substantial Renaissance Revival-style house was built for Charles Farnam, a lawyer. The original design has been attributed to two different architects. In 1898, the northern addition was added.

## C9. 30 HILLHOUSE AVENUE, EDWIN WHEELER HOUSE, 1884

This house was originally a High Victorian design, but its exterior was stripped and stuccoed around 1908.

## C10. 31 HILLHOUSE AVENUE, ABIGAIL WHELPLEY HOUSE, CIRCA 1800; CIRCA 1865: HERNY AUSTIN

This Federal-era house was built around 1800 and subsequently moved here by James Hillhouse for his widowed relative, Ms. Whelpley. Yale Professor and President Noah Porter lived here from the mid-1800s on and he had the house renovated and the mansard roof installed.

## C11. 35 HILLHOUSE AVENUE, MARY PRITCHARD HOUSE, 1836: ALEXANDER JACKSON DAVIS

An ordered and simple Greek Revival design, this house was planned and arranged by James Hillhouse to house a well-to-do widow, Ms. Pritchard. The contractors hired to build the house were Ira Atwater and Nelson Hotchkiss.

## C12. 37 HILLHOUSE AVENUE, GRAVES-GILMAN HOUSE, 1866

This ornate Italian Villa-style house was built by John S. Graves for Professor Daniel Colt Gilman, a librarian and professor at Yale.

## C13. 38 HILLHOUSE AVENUE, HENRY F. ENGLISH HOUSE, 1892: BRUCE PRICE, NEW YORK

This Classical Revival-style house, the last private home built on the avenue, was constructed for Mr. English, a lawyer.

**C14. 43 Hillhouse Avenue, Henry Farnam House, 1871: Russell Sturgis, New York; 1934: Kimball & Husted, New York**
This house was originally designed in a High Victorian style for Mr. Farnam, engineer of the Farmington Canal and then the railroad. In 1934, the house was completely overhauled and its appearance changed to Colonial Revival. The house has been home to Yale University presidents since 1937.

**C15. 46 Hillhouse Avenue, Aaron Skinner House, 1832: Alexander Jackson Davis; 1850s: Henry Austin**
One of New Haven's most elegant and noble homes, this Greek Revival-style house was built for Mr. Skinner, who started a boys' school here. In the 1850s, second-story bays on both sides of the front made a more cubic appearance.

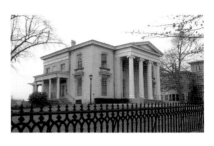

46 Hillhouse Avenue, Aaron Skinner House, March 2007. *Photograph by Colin M. Caplan.*

**C16. 51 Hillhouse Avenue, Graves-Dwight House, 1862**
This fancy, eclectic Victorian house must have changed the calm appearance of the avenue. The house was built for John S. Graves, the secretary and treasurer of the New Haven Gas Company. James M.B. Dwight moved here in 1877.

**C17. 52 Hillhouse Avenue, John Pitkin Norton House, 1848–49: Henry Austin**
One of the earliest Italian Villa-style houses in New Haven, this house's design was influenced by an earlier Andrew Jackson Downing drawing. Norton was a professor of science at Yale.

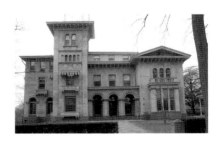

52 Hillhouse Avenue, John Pitkin Norton House, March 2007. *Photograph by Colin M. Caplan.*

**C18. 55 Hillhouse Avenue, Peletiah Perit House, 1860: Sidney Mason Stone**
Modeled after Mason Stone's design for the Ezekiel Trowbridge House on Temple Street (see B11), this Renaissance Revival-style house was built for Mr. Perit, a lawyer and political scientist at Yale.

**C19. 56 Hillhouse Avenue, Elizabeth Apthorp House, 1837: Alexander Jackson Davis**

This Greek Revival–style house has Egyptian Revival–style columns on the front porch. The house, arranged and built by James Hillhouse for the widowed Ms. Apthorp, had numerous additions added over the years.

**C20. 170 Whitney Avenue, Peabody Museum of Natural History, 1923: Charles Z. Klauder, Philadelphia**

Named for George Peabody in 1866, uncle to Yale's own father of paleontology, this Gothic-style building was designed by the same architect who designed Yale's power plants.

**C21. 135 Whitney Avenue, Wayland Cottage, circa 1855**

This Gothic Revival–style cottage was designed as a gatehouse to the large estate of Ezra C. Read, director of the New York, New Haven & Hartford Railroad. Read's son-in-law, Francis Wayland—lawyer, probate judge and dean of the Yale Law School—lived here.

**C22. 265 Bradley Street, Richard Foster Flint House, 1936: Carina Eaglesfield Mortimer**

Considered the city's first modern house, this building has hints of International style and it was dubbed the ice box. Flint was a leading geology and geophysics professor at Yale.

**C23. 254 Bradley Street, Conlan-Clark House, 1850; 1903**

Originally a simple Italian Villa–style house built for Bernard Conlan, an engineer, the house was dramatically altered in 1903 by Charles C. Clark, a French professor at Yale.

**C24. 223 Bradley Street, Casa Bianca, circa 1848; circa 1880**

This Italianate-style house was likely moved here from Orange Street around 1882. By 1911, it was home to George Dudley Seymour, New Haven's City Beautiful leader. Seymour was also a partner in Seymour & Earle, patent solicitors.

**C25. 232 Bradley Street, Everard Benjamin House, 1838: Ithiel Town; circa 1868**

This miniature Greek Revival–style house was built on Orange Street for Mr. Benjamin, a prominent jeweler and silversmith. This was also the birthplace and home of Hobart B. Bigelow, mayor of New Haven and thirty-second governor of Connecticut in 1882. The house was moved here around 1868.

**C26. 40–48 Trumbull Street, Lucius Sperry Row Houses, 1865–70**

The builders of this handsome row of Italianate-style houses, Smith & Sperry, constructed others in the area.

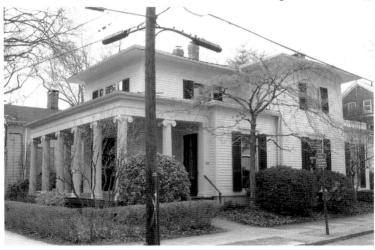

232 Bradley Street, Everard Benjamin House, March 2007. *Photograph by Colin M. Caplan.*

### C27. 1 Lincoln Street, Little Theater, 1924: Gray & Lawrence
Built as a small acting theater guild, this building was changed to a movie house in the 1940s.

### C28. 51 Trumbull Street, John Slade Ely House, 1901: S.G. Taylor, New York
This Tudor-style house was built for Mr. Ely, a physician and professor in the theory and practice of medicine at Yale.

### C29. 58 Trumbull Street, Chaplin-Apthorp House, 1806
This Federal-era house had a very shifty beginning. It was originally built on Whitney Avenue by James Chaplin, but in 1827 the house was moved to Hillhouse Avenue for Elizabeth Apthorp, who opened a school for young ladies in the home. The house was finally moved here in 1838.

### C30. 63–65 Trumbull Street, Dr. Edward S. Gaylord House, 1907: Brown & Von Beren
This Romanesque Revival–style house was built for Dr. Gaylord, a dentist.

### C31. 76–78 Trumbull Street, Berzelius Senior Society, 1910: Don Barber
A Neoclassical-style tomb, this building retains a silence and beauty as a backdrop to a busy intersection.

**C32. 93 Whitney Avenue, Arthur Twining Hadley House, 1880**
This Tudor Revival-style house was modeled after Albrecht Durer's house from 1495 in Nuremberg, Germany. It was built for Mr. Hadley, who was the thirteenth Yale president from 1899 to 1921. Hadley was twenty-four years old when the house was built.

**C33. William Lyon Phelps Triangle, 1824**
This triangular park was set aside by James Hillhouse, who owned much of the surrounding land. The iron and stone fence was installed in 1851.

**C34. 114 Whitney Avenue, New Haven Colony Historical Society, 1929: J. Frederick Kelly**
This amalgamation of Colonial Revival styles attempts to capture New Haven's history. The wrought-iron urns beside the front steps originally came from the demolished Nathan Smith House on Elm Street, site of the Free Public Library (see A8). This society began at City Hall in 1862.

**C35. 442 Temple Street, A.A. Thompson House, 1851**
This Italianate-style house was modeled after Andrew Jackson Downing's designs for a cottage. Mr. Thompson was a partner in the tailoring business of Thompson & Peckham.

**C36. 52 Whitney Avenue, circa 1865**
This light industrial building was used as a storehouse for New Haven Manufacturing Company.

**C37. 33–37 Whitney Avenue, McLagon Foundry, 1870**
This manufacturing building was built for McLagon, Stevens & Co., iron foundry and machinists, which was started in 1848. The wing on Audubon Street was built in 1883.

Tour D.

# *Wooster Square Neighborhood*

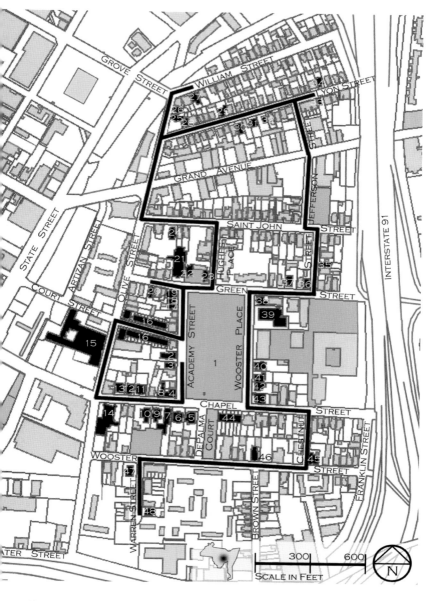

Wooster Square neighborhood walking tour map. *Compiled by Colin M. Caplan.*

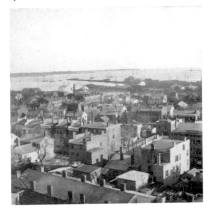

View looking south toward the harbor from the Chapel Street railroad depot, circa 1868. *Photograph by Henry S. Peck. Courtesy of Colin M. Caplan.*

## D1. Wooster Square Park, 1825

This park was sold to the city by Abraham Bishop, and houses were then constructed around the perimeter. Although a wooden fence surrounded the park originally, the present iron fence was installed in 1853.

## D2. 12 Academy Street, Stillman-Greene House, circa 1810

This Federal-era house was built for Ashabel Stillman and later sold to Hannah Greene, widow of Captain Daniel Greene, one of the city's most prominent East and West Indian merchants. The porch was added around 1865.

## D3. 10 Academy Street, William Sears House, circa 1825; circa 1860

Underneath the shell of this Italianate-style house built for Mr. Sears, who was an employee at the appliance store E. Arnold & Co., lies the remains of the Bethel Tuttle House, dating from around 1825.

## D4. 2–6 Academy Street, Lucius Hotchkiss House, circa 1835

This Italian Palazzo-style house was built for Joseph Barber, who was a builder. It was later inhabited by Mr. Hotchkiss, who was a partner with his brother, Henry, in a lumber business and established the Candee Rubber Company, which made boots.

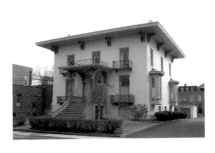

584 Chapel Street, Willis Bristol House, March 2007. *Photograph by Colin M. Caplan.*

## D5. 576 Chapel Street, Henry Hotchkiss House, 1841–42; 1935: Lester J.A. Julianelle

This Art Moderne house was originally a Greek Revival–style house built for Mr. Hotchkiss, a business leader who operated a lumber business and the Candee Rubber Company with his brother, Lucius. In 1863, a third floor was added, but in 1935 the entire building was remodeled.

**D6. 584 CHAPEL STREET, WILLIS BRISTOL HOUSE, 1845: HENRY AUSTIN**
This Moorish Revival–style house was built for Mr. Bristol, head of Bristol & Hall, shoe manufacturers.

**D7. 592 CHAPEL STREET, GOVERNOR JAMES E. ENGLISH HOUSE, 1845: HENRY AUSTIN; 1876**
This Italianate-style house was built for Mr. English, head of a lumber company and the New Haven Clock Company. He also became Connecticut's twenty-fifth governor from 1867 to 1871. In 1876, the third floor was constructed.

**D8. 595–97 CHAPEL STREET, AMOS PARSONS HOUSE, CIRCA 1810**
This Federal-style house was built for Mr. Parsons, a cooper.

**D9. 600 CHAPEL STREET, HENCHMAN S. SOULE HOUSE, 1844**
This Greek Revival–style house was built for Mr. Soule, a sea captain.

**D10. 604 CHAPEL STREET, OLIVER B. NORTH HOUSE, 1852: HENRY AUSTIN**
This Italian Villa–style house was built for Jonathan King, a Cincinnati merchant, and later occupied by Mr. North, head of O.B. North, carriage hardware.

607 Chapel Street, Nelson Hotchkiss House, March 2007. *Photograph by Colin M. Caplan.*

**D11. 607 CHAPEL STREET, HOTCHKISS-BETTS HOUSE, 1854**
This Italianate-style house was built for Nelson Hotchkiss, a partner in Hotchkiss & Lewis, sash and blind makers. In 1875, the house was home to Judge Fred J. Betts.

**D12. 613 CHAPEL STREET, WILLIAM LEWIS HOUSE, 1850**
This Italianate-style house was built for Mr. Lewis, who was partners with Nelson Hotchkiss in a sash and blind manufacturing company.

**D13. 621 CHAPEL STREET, NELSON HOTCHKISS HOUSE, 1850: HENRY AUSTIN**
This Italianate-style house was built for Mr. Hotchkiss prior to the house that was built for him just up the street.

**D14. 620 CHAPEL STREET, ST. PAUL'S EPISCOPAL CHURCH, 1829–30**
This Gothic Revival–style church was built by builder and architect Sidney Mason Stone as a chapel of Trinity Church. The parish

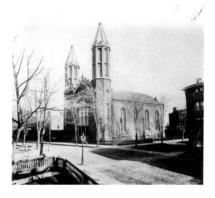

620 Chapel Street, St. Paul's Episcopal Church, circa 1865. *Courtesy of the New Haven Free Public Library.*

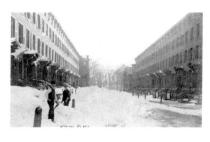

Court Street row houses, circa 1905. *Courtesy of Joseph Taylor.*

became independent in 1845 and the original wooden spires were replaced with stone in 1893.

### D15. 78–84 Olive Street, Strouse, Adler & Company, 1860; 1906: Brown & Von Beren

This corset manufacturing company was started by Isaac Strouse and Max Adler, successors to the country's first corset makers. They moved here in 1877 and were the largest employer in the city at that time. The buildings along Olive Street were added in 1906.

### D16. 83–93 Olive Street and 6–30 Court Street, Home Insurance Company Development Houses, 1869–70

These Italianate-style row houses were developed by the Home Insurance Company. The gateway buildings on the corner of Olive Street were built around the same time.

### D17. 38 Academy Street, Frederick Brown House, 1850

This Italianate-style house was built for Mr. Brown, the head of Brown & Durham Furniture Company.

### D18. 40 Academy Street, Ebenezer Gaylord House, circa 1846; 1872

This Italianate-style house was built for Mr. Gaylord, a brewer at J.J. Phelps Brewery. The house began as two stories and the third floor was added in 1872.

### D19. 42 Academy Street, Edward Rowland House, 1857

This Italianate-style house was built by Smith & Sperry for Mr. Rowland, owner of a wholesale grocery and lumber business. The house is almost identical to 621 Chapel Street (see D13) and 466 Orange Street (see K10), which are both by the same builders.

**D20. 352 GREENE STREET, HARRISON-HOWARTH HOUSE, CIRCA 1845**
This Greek Revival–style house was built for James and Charlotte Harrison. Widowed in 1861, Charlotte sold the house in 1882 to John H. Howarth, a clerk at 765 Chapel Street.

**D21. 329 GREENE STREET, DAVENPORT CONGREGATIONAL CHURCH, 1872: RUFUS G. RUSSELL**
This Victorian Gothic–style church housed for many years St. Casimir's Lithuanian Roman Catholic Church.

**D22. 323 GREENE STREET, HENRY COWELL HOUSE, CIRCA 1870**
This Italian Villa style house was built for Mr. Cowell who owned the Glebe Building, then located on Chapel Street.

**D23. 311 GREENE STREET, MAX ADLER HOUSE, 1879: BROWN & STILSON**
This Stick-style house was built for Mr. Adler, a German Jewish immigrant who eventually headed the Strouse, Adler & Co. corset manufacturers on Olive Street.

**D24. 324 ST. JOHN STREET, CHARLES OSBORN HOUSE, 1843**
This Italian Villa–style house was built for Mr. Osborn, a builder who constructed many of Henry Austin's designs.

**D25. 169 OLIVE STREET, SIDNEY MASON STONE HOUSE, 1848**
This Italianate-style house was built by Mr. Stone as his residence. Stone was a prominent builder and architect and developed much of the surrounding neighborhood, dubbed Stoneville.

**D26. 171–73 OLIVE STREET, IRA MERWIN HOUSE, 1848–50**
This Italianate-style house was built for Mr. Merwin, a broker.

**D27. 104 WILLIAM STREET, FRANKLIN H. HART HOUSE, 1871**
This Italianate-style house was built for Mr. Hart, a clerk.

**D28. 95–97 LYON STREET, MORRIS STEINERT HOUSE, 1895**
This Tudor Revival–style house was built for Mr. Steinert, president of the Steinertone Co., piano dealers. Steinert, who became a dealer in Steinway Pianos in 1869, lived around the corner at 169 Olive Street (see D25).

**D29. 73 LYON STREET, THEODORE WERNER HOUSE, 1844; CIRCA 1875**
This French Second Empire–style house was built for Mr. Werner, a surveyor. The building was originally a two-story Italianate-style house until the third floor was added circa 1875.

## D30. 66 LYON STREET, PHILO CHATFIELD HOUSE, 1858

This Italianate-style house was built by Mr. Chatfield, a partner in Perkins & Chatfield Company, builders.

## D31. 58–60 LYON STREET, AUGUSTUS LINES HOUSE, 1851

This Italianate-style double house was built for Mr. Lines, an engraver.

## D32. 54 LYON STREET, GEORGE GILL HOUSE, 1832–35; 1979

This Greek Revival-style house was built for Mr. Gill, a stucco plasterer. In 1979, the house was saved from demolition and moved here from its original location on Olive Street, near State Street. The house is reputed to have been a part of the Underground Railroad during the nineteenth century.

## D33. 20 LYON STREET, DENISON HALL HOUSE, CIRCA 1850

This Greek Revival-style house was built by Mr. Hall, a joiner for the Lyon family, who owned part of the surrounding land.

## D34. 17 LYON STREET, WILLIAM TODD JR. HOUSE, 1847; CIRCA 1875

This French Second Empire-style house was built by Mr. Todd, a joiner. The house was originally designed in the Italianate style until around 1875, when the third floor was added.

## D35. 175 CHESTNUT STREET, CHRISTIAN WERWEISS BUILDING, 1894

This Romanesque Revival-style apartment flat was built for Mr. Werweiss, a grocer.

## D36. 231 GREENE STREET, JOSEPH BROMLEY HOUSE, 1849; 1860S; 1898: BROWN & VON BEREN

This Italianate and Colonial Revival-style house was built for Mr. Bromley, a store owner. The original house was two stories, but in the 1860s the third story was added. The addition of the wings and porch came in 1898.

## D37. 245 GREENE STREET, WILLIAM DANN HOUSE, CIRCA 1870

This Italianate-style house was built for Mr. Dann, a carriage woodwork manufacturer in the firm Dann Brothers.

## D38. 37–39 WOOSTER PLACE, MAYOR JOHN B. ROBERTSON HOUSE, CIRCA 1833: SYDNEY MASON STONE

This Greek Revival-style house was built for Mr. Robertson, who led a political life being mayor of New Haven, secretary of the state of Connecticut and postmaster.

**D39. 29 WOOSTER PLACE, WOOSTER SQUARE CONGREGATIONAL CHURCH, CIRCA 1855: SIDNEY MASON STONE; 1874; 1904: BROWN & VON BEREN**

The original Greek Revival-style church burned in 1874 and was redesigned. Another fire in 1904 created the present Renaissance Revival-style

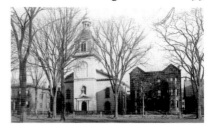

Wooster Place, circa 1900. *Courtesy of Joseph Taylor.*

façade. The building has housed Congregationalists, Baptists and finally Roman Catholics in 1899, who named it St. Michael's.

**D40. 11 WOOSTER PLACE, THERON TOWNER HOUSE, 1843–44**

This Italian Villa-style house was built for Mr. Towner, a shipping merchant.

**D41. 9 WOOSTER PLACE, REVEREND STEPHEN JEWETT HOUSE. 1833; 1872**

This French Second Empire House was built by James English for Theron Towner. Mr. Towner then sold it to Reverend Jewett, a resident Episcopal clergyman. The original house was augmented with the addition of the mansard roof in 1872, following a popular trend.

**D42. 7 WOOSTER PLACE, RUSSELL HOTCHKISS HOUSE, 1844: ITHIEL TOWN; 1873**

This Italianate-style house was built for Mr. Hotchkiss, who worked with his family at Hotchkiss Brothers & Co., shipping merchants. The house is characterized by the cast-iron balconies that were added around 1850. The third floor was added in 1873.

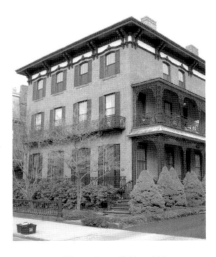

7 Wooster Place, Russell Hotchkiss House, March 2007. *Photograph by Colin M. Caplan.*

**D43. 539–41 CHAPEL STREET, MATTHEW ELLIOT HOUSE, 1832**

This Greek Revival-style house was built for Mr. Elliot, president of the Farmington Canal Company, the New Haven & Northampton Railway and the New Haven

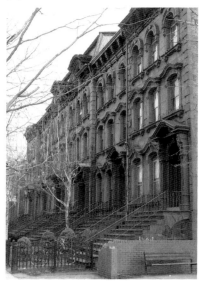

552–62 Chapel Street, row houses, March 2007. *Photograph by Colin M. Caplan.*

& New London Railway. It was later occupied by Paul Russo, an Italian immigrant who became a prominent banker, broker and community citizen.

### D44. 552–62 CHAPEL STREET, ROW HOUSES, 1871: DAVID R. BROWN

Brownstones like these help to add texture and rhythm to the streetscape. These French Second Empire–style houses are the most lavish in the city.

### D45. 121–25 WOOSTER STREET, SOCIETA SANTA MARIA MADDALENA, CIRCA 1870

These buildings were originally built as a row of Italianate-style dwellings. The Society of Santa Maria Maddalena, an Italian American mutual aid group began in 1898 by immigrants from Atrani, Italy, purchased the property in 1906 and used it as their headquarters.

### D46. 157 WOOSTER STREET, FRANK PEPE'S PIZZERIA NAPOLETANA, CIRCA 1880

The first pizza in the world, some say, started right here in 1925 by Frank Pepe. Little did this Italian immigrant know that droves of people from everywhere would wait for hours to get a taste of his family's cooking.

### D47. 224 WOOSTER STREET, JOSEPH PORTER HOUSE, 1879

This Italianate-style house was built for Mr. Porter, who worked at Sperry & Barnes, a slaughterhouse on Long Wharf.

### D48. 49 WARREN STREET, HARMANUS WELCH HOUSE, 1849: HENRY AUSTIN

This curious Italianate-style house was built for Mr. Welch, business leader and mayor of New Haven.

# Trowbridge Square Neighborhood

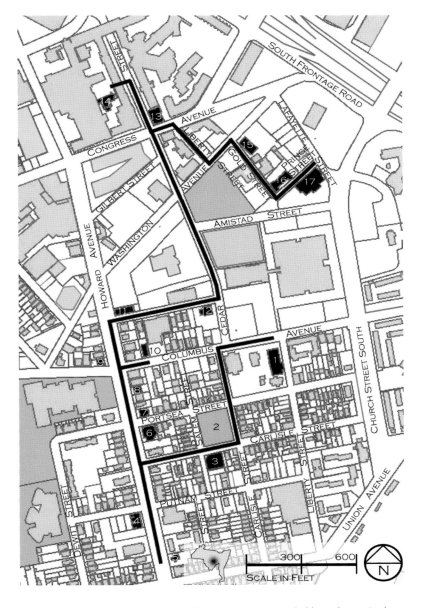

Trowbridge Square neighborhood walking tour map. *Compiled by Colin M. Caplan.*

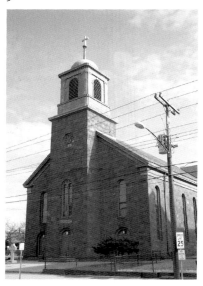

198 Columbus Avenue, South Congregational Church, March 2007. *Photograph by Colin M. Caplan.*

### E1. 198 COLUMBUS AVENUE, SOUTH CONGREGATIONAL CHURCH, 1851: SIDNEY MASON STONE

Paid for by Gerard Hallock, an entrepreneur who had pro-slavery sentiments, this Italianate-style church became Sacred Heart Roman Catholic Church in 1875.

### E2. SPIREWORTH SQUARE, CIRCA 1835

This small park was the center of a nine-block development mimicking the old city center. Nathaniel and Simeon Jocelyn, real estate speculators, artists and social reformers, attempted to create a community out of this slum known as Mount Pleasant. The park was named Trowbridge Square after the family that eventually built numerous houses in the area.

### E3. 158–60 CARLISLE STREET, SPIREWORTH SCHOOL, 1925: BROWN & VON BEREN

This Colonial Revival–style school building was constructed as a trade school.

### E4. 518–26 HOWARD AVENUE, ROBERT DUBOIS BUILDING, 1892

Mr. Dubois built this Romanesque Revival–style apartment block on land formerly occupied by his father's estate.

### E5. 493 HOWARD AVENUE, CIRCA 1872

This Gothic Revival–style house was once one of the avenue's large estates. In 1883, this was home to Nehemiah H. Hoyt Jr., a partner in Lee & Hoyt, wholesale butchers at Custom House Square on Long Wharf.

### E6. 577 HOWARD AVENUE, GRACE METHODIST EPISCOPAL CHURCH, 1889

This Romanesque Revival–style church was organized in 1872.

### E7. 583–85 HOWARD AVENUE, GEORGE W.L. BENEDICT HOUSE, 1881

This Queen Anne–style double house was built for Mr. Benedict, head of Benedict & Company, coal and wood suppliers.

649 Howard Avenue, Police Station 3, March 2007. *Photograph by Colin M. Caplan.*

### E8. 599–601 HOWARD AVENUE, CIRCA 1891

This Queen Anne–style double house was most likely built for Ezekiel Hayes Trowbridge as a speculative real estate development.

### E9. 622 HOWARD AVENUE, NICHOLAS COUNTRYMAN HOUSE, 1865: RUFUS G. RUSSELL

This Stick-style house was built for Mr. Countryman, one of the city's leading builders and a manufacturer of blinds, doors and sashes.

### E10. 261–63 COLUMBUS AVENUE, GERMAN METHODIST EPISCOPAL CHURCH, 1907

Designed similar to the multi-unit flats in the area, this Queen Anne–style church is distinguished by its small tower.

### E11. 649 HOWARD AVENUE, POLICE STATION 3, 1891: DAVID R. BROWN WITH FERDINAND VON BEREN

It seems the police needed a small Gothic-style fortress to show the neighborhood who was boss. This precinct was in operation until 1955.

### E12. 226 CEDAR STREET, MARCHEGIAN CLUB, 1937

This Art Moderne–style clubhouse was the third largest Italian American club in the country with almost four thousand members.

### E13. 321 CONGRESS AVENUE, JANE ELLEN HOPE BUILDING, 1901

Once an independent health care agency for the city's working class, the New Haven Dispensary, started in 1871, built this Romanesque Revival–style building.

226 Cedar Street, Marchegian Club, March 2007. *Photograph by Colin M. Caplan.*

### E14. Cedar Street, East Wing New Haven Hospital, 1872
Added onto the original General State Hospital of 1830, this Chateauesque-style building provided needed room to the growing institution.

### E15. 70 Washington Avenue, St. Anthony's Roman Catholic Church, 1903: Richard Williams
Based on a Renaissance-style church in Italy, the parish tried to bring a sense of the old country to the Hill.

### E16. 49 Prince Street, St. Anthony Home, 1930
Again mimicking the Renaissance style, this dormitory building was built as an orphanage for the Sisters of the Sacred Heart.

### E17. 46 Prince Street, Prince Street School, 1909: Brown & Von Beren
This Renaissance Revival–style school building was spared during the 1960s redevelopment and was reused. The area was once a melting pot for immigrants and the working class.

Tour F.

# *Hill Neighborhood*

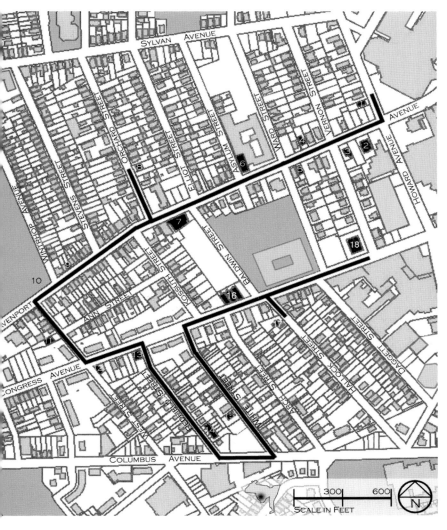

Hill neighborhood walking tour map. *Compiled by Colin M. Caplan.*

**F1. 836 Howard Avenue, George Treat House, 1886**
This Queen Anne–style house was built by Mr. Treat, a mason and builder, along with his father who lived in the house to the right.

**F2. 110–12 Davenport Avenue, James E. Kelley House, circa 1884–85**
Mr. Kelly, owner of a cement and gravel roof construction company, built this Italianate-style double house.

**F3. 122 Davenport Avenue, Reverend John E. Searles House, 1864**
This Gothic Revival–style house was built for Reverend Searles, pastor of the George Street Methodist Episcopal Church.

**F4. 135 Davenport Avenue, 1860–67**
This unusual Gothic Revival–style cottage mimicked the house of Reverend Jared B. Flagg, which once was located a few doors down.

**F5. 146 Davenport Avenue, James E. McGann House, 1888**
This Queen Anne–style house was built for Mr. McGann, a real estate broker.

**F6. 169 Davenport Avenue, Jewish Home for the Aged, 1921–23: Brown & Von Beren**
This benevolent society began in 1915 and purchased a house on this site in 1916. The need for more space required the building of this Renaissance Revival–style building.

**F7. 206–16 Davenport Avenue, White Way Theater, 1915**
Neighborhood theaters often included stores and apartments in front. Although the theater was torn down in 1997, this simple but robust front is still intact.

**F8. 29–31 Orchard Street, circa 1770; circa 1868**
A Colonial-era house in its guts, this building was moved here around 1868, possibly by Reverend Jared B. Flagg, acting rector of St. James Episcopal Church in Westville and noted portrait artist. The house gained a rear addition in 1869 and a storefront in 1912; the latter was removed in 2002.

**F9. 277 Davenport Avenue, circa 1855**
This transitional Greek Revival and Italianate–style house was the only house on the block until the neighborhood was developed in the 1860s.

**F10. Evergreen Cemetery, 1848; 1898: Leoni Robinson**
The legend of Midnight Mary lives here at the grave of Mary E. Hart, who in 1872 was believed to be dead and buried. But upon exhuming the grave, her family found that she had struggled. The grave reads,

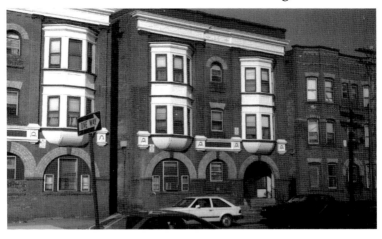

627–19 Congress Avenue, January 1997. *Photograph by Colin M. Caplan.*

"The people shall be Troubled at Midnight and Pass Away." The iron fences were installed in 1872 and the old chapel was built in 1898.

### F11. 210 WEST STREET, PHILLIP FRESENIUS HOUSE STABLE, 1889: CLARENCE H. STILSON
This Queen Anne–style stable was built for Mr. Fresenius, owner of a brewery across the street.

### F12. 798 CONGRESS AVENUE, GEORGE BOHN BUILDING, 1890
This Romanesque Revival–style building was built by George Bohn & Sons, mason builders who lived next door.

### F13. 744–50 CONGRESS AVENUE, JOHN A. MILLER BUILDING, 1883
Mr. Miller, owner of a butcher shop and store called the Eagle Drug Store, had this Italianate-style brick block constructed.

### F14. 11–19 REDFIELD STREET, CIVIL WAR BARRACKS, CIRCA 1865
This plain residential row is rumored to have housed wounded troops from the Ninth Regiment Volunteers during the Civil War.

### F15. 30 WHITE STREET, AHAVAS SHALOM SYNAGOGUE, 1927
This Byzantine Revival–style synagogue replaced a wood-frame structure on the same site. The congregation ceased in 1969 after most of its members left the neighborhood.

### F16. 627, 625, 619 CONGRESS AVENUE, 1897: BROWN & VON BEREN
Dubbed the three sisters, these Queen Anne–style apartments were some of the most fashionable in the Hill.

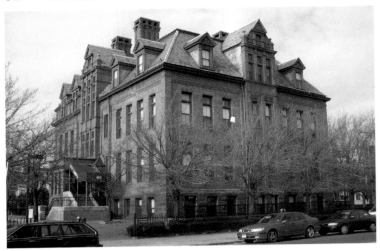

495 Congress Avenue, Welch Training School, March 2007. *Photograph by Colin M. Caplan.*

### F17. 86 Hallock Street, Massena Clark House, circa 1869–76

Built for Mr. Clark, a real estate speculator, this mansard roof house is the only extant octagonal building in New Haven. This shape was popularized by Orson Fowler, a writer.

### F18. 495 Congress Avenue, Welch Training School, 1883: Leoni Robinson

One of the most outstanding school buildings in the city, this Queen Anne–style building was named for Harmanus M. Welch, New Haven's sixteenth mayor, and was the first city school to have a kindergarten in 1885.

Tour G.

# Dwight Neighborhood

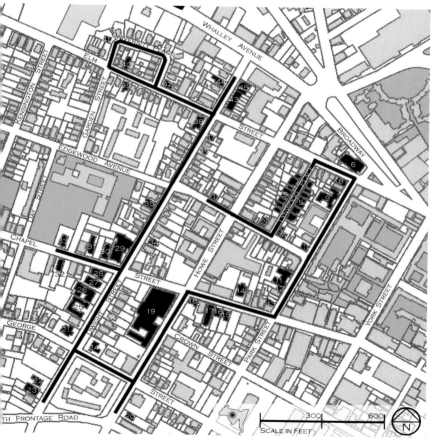

Dwight neighborhood walking tour map. *Compiled by Colin M. Caplan.*

### G1. 61 Edgewood Avenue, circa 1797; circa 1851–59

The evidence for this house's age comes from its post and beam construction method. Dwight's oldest existing house was moved to this site between 1851 and 1859.

### G2. 33 Edgewood Avenue, Albert D. deBussy House, 1891

This Queen Anne–style house was built for Mr. deBussy, a bookkeeper when the house was constructed.

### G3. 21 Edgewood Avenue, circa 1845

Best known for being President Bill and Hillary Clinton's first home together in 1971, this Italianate-style house was likely remodeled in the 1870s.

### G4. 27–17 Edgewood Avenue, circa 1835

This mix of Federal- and Greek Revival–style house is an excellent example of the transition of style and customs in housing construction in the early nineteenth century.

### G5. Lynwood Place, circa 1875–1936

This residential street opened for development beginning in 1882 and the last building was constructed in 1936. It is one of the only streets in the city where all of the houses are built of brick.

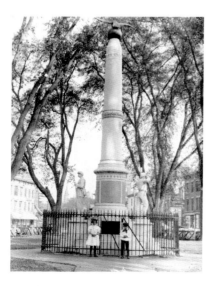

Broadway Square, circa 1910. *Courtesy of Joseph Taylor.*

### G6. 70 Broadway, Christ Church, 1894–95 and 1898: Henry Vaughn, Boston

Begun as a parish of Trinity Church, this congregation became independent in 1856. They built this striking Gothic-style church and completed the tower in 1898.

### G7. Broadway Triangle, circa 1820; 1905

Elm trees were planted here around 1820 and this wide conjunction of streets became one of the city's most picturesque places. The monumental column was erected in 1905 in memory of the soldiers of the Civil War.

**G8. PARK STREET, FIREHOUSE 3, 1865; CIRCA 1875; CIRCA 1942**
Barely recognizable today as a fire station, this building started as a
one-story firehouse and was expanded and remodeled around 1875,
and again around 1942.

**G9. 268–76 PARK STREET, ST. THOMAS MORE CHAPEL, 1937:
DOUGLAS ORR**
Considered modern in design when it was constructed, this Colonial
Revival–style church provides the Yale community with Catholic
services.

**G10. 234–36 PARK STREET, CIRCA 1815**
One of the area's earliest extant buildings, this Federal-era double
house was built before the street became an industrial center in the
mid-1800s.

**G11. 210–20 PARK STREET, MATHUSHEK MANUFACTURING
COMPANY, 1867; 1912**
This Mission-style apartment building was remodeled into an
apartment block called Harrison Court in 1912. It was originally built
as a piano factory by a noted piano maker, Frederick Mathushek.

**G12. 206 PARK STREET, CIRCA 1840**
This Greek Revival–style house was built when the area was becoming
a manufacturing center.

**G13. 196–98 PARK STREET, GENERAL HENRY S. PECK HOUSE, 1898:
WILLIAM E. AUGUR**
This Romanesque Revival–style apartment was built by Mr. Peck,
inspector general of the Thirty-fourth National Encampment in
1900.

**G14. 1201 CHAPEL STREET, DR. JOHN H. KLOCK HOUSE, CIRCA
1847; 1875**
This Victorian-style mansion was overhauled with a new roof and
other alterations by Dr. Klock, who ran a drugstore down the street.

**G15. 1204 CHAPEL STREET, JAMES OLMSTEAD HOUSE, 1858**
This late Greek Revival–style house was built for Mr. Olmstead, owner
of a drugstore on Broadway.

**G16. 1210 CHAPEL STREET, 1858; CIRCA 1875**
Like a number of the city's elegant French Second Empire–style
houses, a major renovation around 1875 altered this building from its
original design.

### G17. 1214 CHAPEL STREET, HADDON HALL APARTMENTS, 1921: FRANK ELMWOOD BROWN

Apartment buildings like this Tudor Revival–and Italian Palazzo–style mix were constructed in this neighborhood the 1920s in response to a surge in housing demand.

### G18. 1226 CHAPEL STREET, ELM CITY DINER, 1955

This is one of the city's prefabricated metal diners built by Harold and Jack Berkowitz, who ran a Duchess Diner here.

### G19. 44–52 HOWE STREET, YMCA AND YWCA, 1924 AND 1931: DOUGLAS ORR

The need for more recreational activities for the city's youth was met by the construction of these large Tudor Revival–style buildings.

### G20. 19 HOWE STREET, SHERMAN F. FOOTE HOUSE, 1885

This elaborate Queen Anne–style house was built for Mr. Foote, secretary treasurer of the Seamless Rubber Company.

### G21. 501 GEORGE STREET, DEAN-DAWSON HOUSE, 1836: ALEXANDER JACKSON DAVIS; CIRCA 1875; 1882

This French Second Empire–style house, built as a double house for Mr. Dean, was home to Henry S. Dawson, a partner in Dawson, Douglas & Co., fruit and confections. The mansard roof was likely added in 1875 when Joseph Parker, head of the Joseph Parker & Sons paper mill in Westville, moved here. Other additions were added in 1882.

19 Howe Street, Sherman F. Foote House, March 2007. *Photograph by Colin M. Caplan.*

### G22. 56 DWIGHT STREET, SMITH MERWIN HOUSE, CIRCA 1862 OR CIRCA 1864

Both Dwight and Howe Streets were fashionably laid out with large houses during the mid-nineteenth century. This is one of the only ones left, designed in the Italian Villa style and built for Mr. Merwin, a merchant tailor.

**G23. 48 DWIGHT STREET, ST. BARBARA GREEK ORTHODOX CHURCH, 1941–42: CHARLES H. ABRAMOWITZ**
Founded in 1919, the parish begun by Greek immigrants built this Moorish Revival–style church.

**G24. 95 DWIGHT STREET, CLARENCE BLAKESLEE HOUSE, 1914: ROY W. FOOTE; 1969**
This Colonial Revival–style home was built for Mr. Blakeslee, who ran C.W. Blakeslee, contractors, with his family. Blakeslee was responsible for financing civil rights lawyer and Judge Constance Baker Motley's higher education in the 1940s. The house was saved from demolition and moved from the opposite side of George Street in 1969.

**G25. 102–16 DWIGHT STREET, EMBASSY APARTMENTS, 1924: LESTER J.A. JULIANELLE**
This Classical and Mission–style apartment building utilizes a horseshoe plan to allow maximum lighting to apartments.

**G26. 120 DWIGHT STREET, TRAYMORE APARTMENTS, 1926**
One of the largest apartment buildings in the neighborhood, it was designed in a Neoclassical style.

**G27. 128 DWIGHT STREET, FREDERICK P. NEWTON, 1894: WILLIAM H. ALLEN**
This Queen Anne–style house used to share the block with other stately houses, which were called Dwight Place. This house became a funeral home in 1929.

**G28. 136 DWIGHT STREET, DWIGHT APARTMENTS, 1918: JACOB M. FELSON, NEW YORK**
This Renaissance Revival–style apartment building is noted for being the home of Otto and Matilda Caplin, cartoonist Al Capp's parents, in the 1930s.

**G29. 1267 CHAPEL STREET, DWIGHT PLACE CONGREGATIONAL CHURCH, 1871: DAVID R. BROWN**
This Italianate-style church once had three spires and was one of the earliest examples in the use of concrete masonry units in New Haven.

1267 Chapel Street, Dwight Place Congregational Church, circa 1875. *Courtesy of the New Haven Free Public Library.*

1287 Chapel Street, Franklin S. Bradley House, March 2007. *Photograph by Colin M. Caplan.*

### G30. 1275 CHAPEL STREET, WESTOVER APARTMENT HOUSE, 1923

Here is another example of a Neoclassical-style apartment building.

### G31. 1287 CHAPEL STREET, FRANKLIN S. BRADLEY HOUSE, 1877: RUFUS G. RUSSELL

This is one of the richest Victorian Gothic-style houses in the city. It was built for Mr. Bradley, who operated F.S. Bradley & Company, hardware and machine supplies.

### G32. 1302–04 CHAPEL STREET, GEORGE R. HODGDON HOUSE, 1893

This Queen Anne–style house was built for Mr. Hodgdon, proprietor of the Tontine Hotel.

### G33. 1303–05 CHAPEL STREET, LEVERETT L. CAMP HOUSE, CIRCA 1865

From 1905 to 1923, this was home to Walter Camp, father of American football. This French Second Empire home was built for his father, Leverett, principal of the Washington School.

### G34. 169 DWIGHT STREET, ROBERT MOSES HOUSE, CIRCA 1878

Robert Moses, New York City planner and power broker, was born in this house in 1888 and lived here with his parents, German Jewish immigrants. They moved to New York City in 1897.

### G35. 188 DWIGHT STREET, CIRCA 1840

This was once a common Greek Revival–style house, many of which are still found in this area.

### G36. 235 DWIGHT STREET, 1863, SAMUEL C. TOMPKINS HOUSE

This Greek Revival–style house was built for Mr. Tompkins, a wheel maker.

### G37. 245 DWIGHT STREET, CIRCA 1845; CIRCA 1895

Although this house was originally designed in the Greek Revival style, somebody who wanted to live in fashion added the Queen Anne–style porch and tower.

**G38. 424 Elm Street, John Richardson House, 1844; 1934**
On its one hundredth anniversary, this Greek Revival–style house built for Mr. Richardson had a makeover with the addition of the two-story columns.

**G39. 474–76 Elm Street, circa 1888**
This building was a common Queen Anne–style double house built between 1890 and 1900.

**G40. 477–79 Elm Street, George C. and Margaret Cross Building, 1910**
This Italianate-style apartment flat was built for Mr. and Mrs. Cross, who lived there for a year.

**G41. 23 University Place, circa 1870**
This Victorian Gothic–style house was built after Mr. Grinnell's carriage factory burned around 1870 on the same site. The house became home to Miss Annie L. Bradley in 1878.

**G42. 1 University Place, George H. Pfaff House, 1887; 1900: Charles E. Berger**
This Queen Anne–style house was built for Mr. Pfaff, who worked with his family at L.C. Pfaff & Son, meat market. In 1900, the two-story wing with the tower was added.

**G43. 267–77 Dwight Street, circa 1874**
This fashionable Italianate-style row is the only substantial brick row existing in an area that used to have a number of rows.

**G44. 276 Dwight Street, Alexander Thayer House, circa 1864; circa 1898**
This Victorian Gothic–style house was built for Mr. Thayer. The lavish porch, tower and porte cochère were added around 1898.

**G45. 279 and 283–85 Dwight Street, Garwood M. Baldwin Buildings, circa 1887**
These Italianate-style apartment flats were built for Mr. Baldwin on land that formerly housed the evangelists Moody and Sankey's Tabernacle. This large wood-frame hall with a capacity of ten thousand people was built in 1876, converted to an ice skating rink and taken down in 1885–86.

# Edgewood and West River Neighborhoods

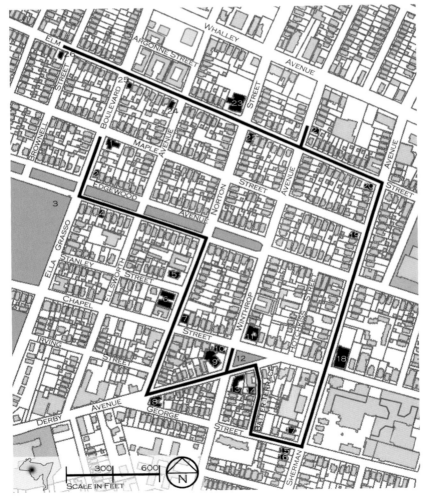

Edgewood and West River neighborhoods walking tour map. *Compiled by Colin M. Caplan*

**H1. 1377 Ella Grasso Boulevard, Michael Kipp House, 1898**
This Queen Anne–style house was built for Mr. Kipp on land previously purchased from the Trustees of the New Haven Almshouse Farm, which was once located a block away.

**H2. 469 Edgewood Avenue, Dennis Manning House, 1895**
This Queen Anne–style house was built for Mr. Manning, a conductor with the New York, New Haven & Hartford Railroad.

**H3. Edgewood Park, 1889, Donald Grant Mitchell and Frederick Law Olmsted Jr.**
This park was created by Mr. Mitchell, a prolific author during the mid- to late nineteenth century, and Mr. Olmsted, son of the designer of New York City's Central Park. The park's name is derived from Mr. Mitchell's adjacent farm, which he named Edgewood. The West River that runs through the center of the park was straightened, creating curious murky oxbow ponds.

**H4. 454 Edgewood Avenue, Frank J. Schollhorn House, 1897: Brown & Von Beren**
This Queen Anne–style house was built for Mr. Schollhorn, the secretary and treasurer of the William Schollhorn Company.

**H5. 84 Norton Street, Mead-Blakeslee House, 1853–55; 1909: Allen & Williams**
Originally, this Colonial Revival–style mansion was an isolated farmhouse built for Solomon Mead. The third floor, front porch and other alterations were built in 1909 after it was purchased in 1903 by Theodore R. Blakeslee, vice-president of the Bradley Smith Co., provisions dealer.

**H6. 66–68 Norton Street, the Stanwood Apartment Building, 1920: D'Avino & Marchetti**
Large apartment buildings were constructed in the area in the 1920s, replacing the older farm estates. The Stanwood was designed in the Mission style.

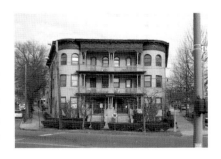

1–3 Norton Street, Glendorf Apartments, March 2007. *Photograph by Colin M. Caplan.*

**H7. 1565–67 Chapel Street, Phillip Fresenius House, 1902: Brown & Von Beren**
Before the storefront and vinyl siding, this was an elegant Colonial Revival– and Tudor-style house. The house was built for Mr. Fresenius, head of the Philip Fresenius & Sons Brewing Company.

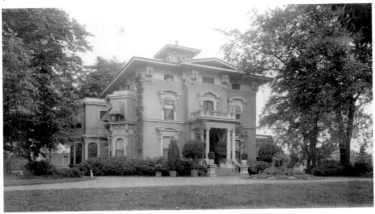

28 Batter Terrace, Edward Malley House, circa 1905. *Courtesy of Joseph Taylor.*

### H8. 1–3 NORTON STREET, THE GLENDORF APARTMENTS, 1913–14
This Neoclassical-style apartment building was built for Meyer Arrick, a real estate broker. World-famous bandleader Artie Shaw's mother moved into this building in 1926.

### H9. 278 WINTHROP AVENUE, FIRST CHURCH OF CHRIST SCIENTIST, 1910: ALLEN & WILLIAMS
This Colonial Revival–style church adds a sense of civic grace to the neighborhood.

### H10. 280 WINTHROP AVENUE, SIMON J. HUGO HOUSE, 1898: BROWN & VON BEREN
This fashionable Queen Anne mansion was built for Mr. Hugo, owner of a delicatessen and sausage manufacturing company.

### H11. 1521–23 CHAPEL STREET, WINTHROP TERRACE APARTMENTS, 1922
Another large apartment building in the immediate area, this one is designed in an Italian Palazzo style.

### H12. MONITOR PARK, CIRCA 1840
The statue honors Bushnell and Ericson, builders of the Civil War ship the *Monitor*. The park was originally called Samaritan Park, named after the old almshouse once located in the neighborhood.

### H13. 36 DERBY AVENUE, DERBY TERRACE APARTMENTS, 1922: BROWN & VON BEREN
This Mission-style apartment building sits on a knoll behind an inviting corner entryway.

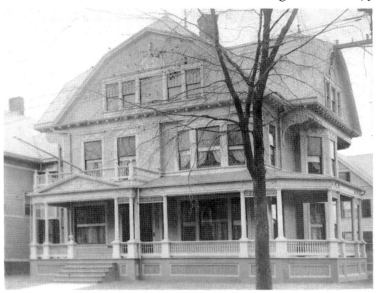

232 Sherman Avenue, Julius D. Hildreth House, March 1906. *Courtesy of Joseph Taylor.*

### H14. 28 BATTER TERRACE, EDWARD MALLEY HOUSE, 1858; CIRCA 1920

Mr. Malley, an Irish immigrant who started in the dry goods business in 1854 and ran one of the most successful department stores in the city's history, built this Italian Villa–style house. This was the largest estate in the area, and when it was subdivided around 1920 the house was rotated away from Derby Avenue.

### H15. 110 SHERMAN AVENUE, CHARLES NICKLAS HOUSE, 1899: BROWN & VON BEREN

This Queen Anne–style house was built for Mr. Nicklas, a brewer at Weibel's brewery.

### H16. 114 SHERMAN AVENUE, THERESA WEIBEL HOUSE, 1899: BROWN & VON BEREN

Built at the same time as Charles Nicklas's house, this Queen Anne–style house was built for Ms. Weibel, treasurer of her late husband's brewery on Oak Street.

### H17. 120 SHERMAN AVENUE, GEORGE ALLING HOUSE, 1867: RUFUS G. RUSSELL

This French Second Empire–style house was built for Mr. Alling, entrepreneur and a partner of G&T Alling, a lumber business he headed with his brother, Thomas.

### H18. 1467–69 CHAPEL STREET, PLYMOUTH CONGREGATIONAL CHURCH, 1900: WILLIAM H. ALLEN

This Richardson Romanesque–style church is a strong marker at this corner.

### H19. 232 SHERMAN AVENUE, JULIUS D. HILDRETH HOUSE, 1895

This Queen Anne house was built for Mr. Hildreth, who ran J.D. Hildreth & Son, carpenters and builders.

### H20. 262 SHERMAN AVENUE, JAMES A. CHURCH HOUSE, 1893: WILLIAM H. ALLEN

This striking Queen Anne house was built for Mr. Church, a contractor.

### H21. 407 WINTHROP AVENUE, A.W. FLINT & CO. BUILDING, 1902

This frame barn was built for Adelbert W. Flint's chair and ladder manufactory.

### H22. 748–50 ELM STREET, FRATTARI-SPAZIANTE DEVELOPMENT HOUSE, 1909–10: BAILEY & D'AVINO

This elegant Colonial Revival–style house was built by Ettore Frattari and Mr. C. Spaziante, who built the two adjacent houses at the same time. The house was sold to the Williams family, including Albert, who was an orchestra conductor.

### H23. 765 ELM STREET, ROGER SHERMAN SCHOOL, 1896: LEONI ROBINSON

This Colonial Revival–style school building was named for New Haven's first mayor and the only person to sign the Declaration of Independence, Articles of Confederation, Articles of Association and the U.S. Constitution.

### H24. 808 ELM STREET, FRANK BRAZOS HOUSE, 1893: BROWN & STILSON

This Queen Anne–style house was built for Mr. Brazos, a sewer, stone and paving contractor.

### H25. 844 ELM STREET, JESSE RUSSELL HOUSE, 1894: BROWN & BERGER

This Queen Anne–style house was built for Mr. Russell who worked at the Price & Lee Co., publishers of city directories.

### H26. 890 ELM STREET, WATSON GOODYEAR HOUSE, 1918

This Prairie-style house was built for Mr. Goodyear, a partner in the firm Baker, Goodyear & Associates, accountants.

Tour I.

# Dixwell Neighborhood

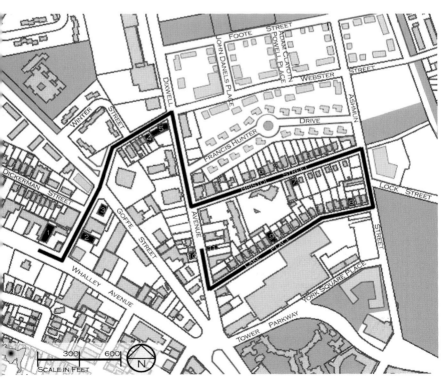

Dixwell neighborhood walking tour map. *Compiled by Colin M. Caplan.*

## 11. 113 Whalley Avenue, St. Luke's Church, 1905: Brown & Von Beren

The third oldest African American Episcopal church in the country, St. Luke's was organized by the local black Episcopal community in 1844, and they later built this Gothic Revival–style church.

## 12. 31 Sperry Street, Bethel African Methodist Episcopal Church, 1882; 1929

This Gothic Revival church was built by this congregation, which began around 1840 in the area, an early African American neighborhood. The building was remodeled in 1929 to its present façade.

106 Goffe Street, Goffe Street Special School, March 2007. *Photograph by Colin M. Caplan.*

## 13. 106 Goffe Street, Goffe Street Special School, 1864: Henry Austin

Sally Wilson started this school in 1854 in her home, but it closed in 1874 after the schools were desegregated. In 1929, the building became a Masonic hall. The plan for this school for black pupils was donated by the architect.

## 14. 94 Webster Street, Union African Methodist Episcopal Church, 1852; 1940

This Gothic Revival–style church was originally located one block up and was a wood-frame structure. In 1940, when Elm Haven Housing Project was built, the building was moved, remodeled and clad with brick.

## 15. 138 Dixwell Avenue, Police Station 4, 1905–06: Brown & Von Beren; 1948

This Renaissance Revival–style building replaced a house used as the police precinct. In 1942, the building was sold and converted to a community center. In 1948, St. Martin DePorres added the rear wing and remodeled the building.

## 16. 105 Bristol Street, Hubert Allen House, 1875

This small Italian Villa–style house was built for Mr. Allen, a machinist.

## 17. 80 Bristol Street, John Albert Osgood, circa 1880

Another diminutive Italian Villa–style house, this one was built for Mr. Osgood, a tinner.

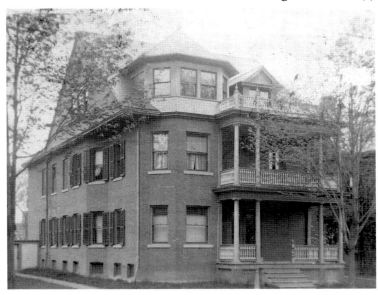

61–63 Lake Place, George H. Pond House, May 1907. *Courtesy of Colin M. Caplan.*

### I8. 11 Lake Place, Augustus Kaiser House, 1891
This Queen Anne–style multi-family house was built for Mr. Kaiser, a confectioner.

### I9. 61–63 Lake Place, George H. Pond House, 1905: William D. Johnson, Hartford
This Colonial Revival–style multi-family house was built for Mr. Pond, secretary and treasurer of the Lightbourn & Pond Co. hardware store on Broadway.

### I10. 48–50 Dixwell Avenue, Aeneas Munson House, 1830
Mr. Munson was the son of the prominent physician Aeneas, and he built this Federal-style house, the earliest existing building in the neighborhood.

### I11. 51–53 Dixwell Avenue, Stein-Rourke Tenant Building, 1898
This Colonial Revival–style mixed-use building was built by Isadore Stein and Frank A. Rourke.

# Tour J.

# *Newhallville Neighborhood*

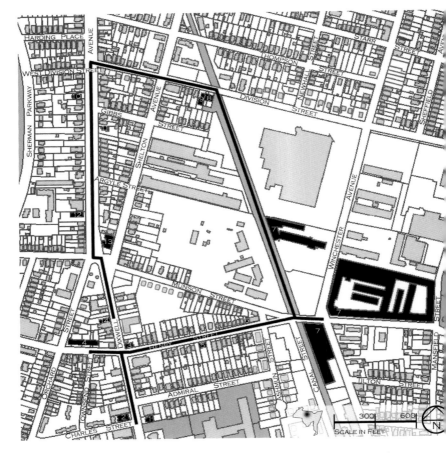

Newhallville neighborhood walking tour map. *Compiled by Colin M. Caplan.*

**J1. 235 Dixwell Avenue, Albert Tilton House, 1876**
This Gothic Revival–style house was built for Mr. Tilton, a gun maker at the nearby Winchester Repeating Arms Company. In 1911, the Hannah Gray Home for poor, older African American women moved here.

**J2. 240 Dixwell Avenue, Varick Memorial African Methodist Episcopal Church, 1908: Brown & Von Beren**
This Gothic Revival–style church was built by this congregation, which formed in 1818. In 1915, Booker T. Washington, African American educator and community leader, made his last public speech here before his death.

240 Dixwell Avenue, Varick Memorial African Episcopal Methodist Church, March 2007. *Photograph by Colin M. Caplan.*

**J3. 287 Dixwell Avenue, Adolf A. Eisele Building, 1885; 1897–98**
This Colonial Revival–style mixed-use building was moved closer to the street and then had additions built and alterations made in 1897–98. This work was done for Mr. Eisele, a German immigrant who ran a grocery store here.

**J4. 127–47 Henry Street, John Carrington Row Houses, 1875**
Mr. Carrington, owner of Carrington & Co., publishers of the *Journal Courier* newspaper, built these French Second Empire–style row houses for the growing demand of the Winchester Repeating Arms Company workers.

**J5. 58–62 Henry Street, Joseph Sheldon Tenant Houses, 1878**
This was another investment property built during this time by Mr. Sheldon, a city court judge and lawyer. This short row is designed in Italianate style.

**J6. 27–29 Henry Street, Joseph Sheldon Tenant House, 1884; 1915: Shiner & Appel**
Originally built as a small Victorian Gothic–style house by Mr. Sheldon, this building was altered and enlarged for Damon Holmes's restaurant.

**J7. 275 Winchester Avenue, Winchester Repeating Arms Company, 1870; 1883; 1892–1916 and 1932: Leoni Robinson**
Founded by Oliver Winchester in 1866, this sprawling plant covered eighty-one acres and was the largest employer in the city at its peak during

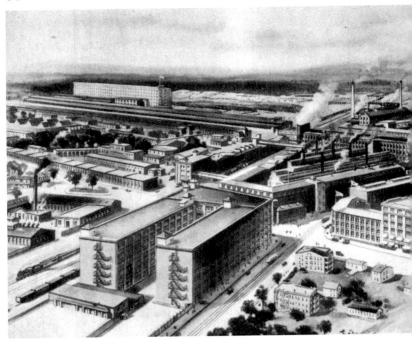

Winchester Repeating Arms Company, circa 1920. *Courtesy of Colin M. Caplan.*

the World Wars. The factory was built near the site of the George T. Newhall Carriage Emporium in the neighborhood called Newhallville.

### J8. 220–26 DIVISION STREET, GEORGE W. GOODSELL ROW HOUSES, CIRCA 1875

This Italianate-style row was built for Mr. Goodsell, a wholesale grocer. Wood-frame rows are rare in New Haven, as most row houses were built within the brick fire district.

### J9. 230 DIVISION STREET, PLEASANT VALLEY CHAPEL, 1870

This tiny Victorian Gothic–style church was built for the New Haven City Missionary Society to assist the small hamlet of Winchester Repeating Arms Company workers.

### J10. 482 DIXWELL AVENUE, GLOSON HALL HOUSE, 1856; CIRCA 1925

This Italian Villa–style house was built for Mr. Hall, who ran a meat market downtown. Around 1925, a rear addition almost doubled the size of the house.

### J11. 459 DIXWELL AVENUE, ASPINWALL-CUTTENDEN HOUSE, 1875

This Italianate-style house was built for Oliver C. Aspinwall, a wheelwright. He then sold it to Seth Cuttenden, a produce dealer.

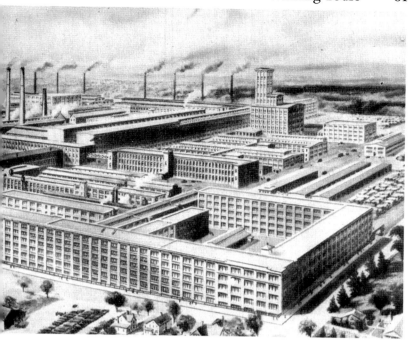

### J12. 388 DIXWELL AVENUE, HOOK AND LADDER 4, 1905: BROWN & VON BEREN

Designed in a Neoclassical style, this former firehouse closed in 1975.

### J13. 363 DIXWELL AVENUE, SUMMERFIELD UNITED METHODIST CHURCH, 1891–92

Begun as the first Methodist congregation in Newhallville in 1871, the church later built this Gothic Revival-style building. In 1981, the church merged together with the First Methodist Church on Elm Street (see B5).

### J14. 310 DIXWELL AVENUE, THE SUBURBAN HOME SCHOOL, CIRCA 1850; 1895

Reverend Alonzo G. Shears was the rector of an all boys' school begun in 1855 that included this Italianate-style building. After the school closed, this building was moved to the street in 1895.

# Tour K.

# *State Street Neighborhood*

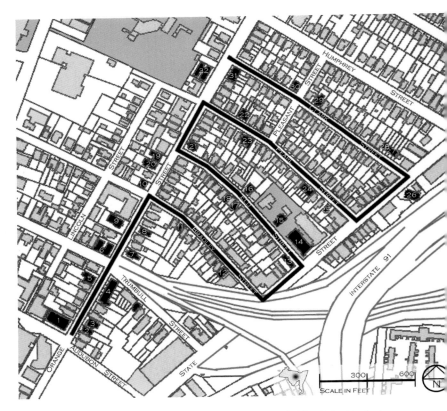

State Street neighborhood walking tour map. *Compiled by Colin M. Caplan.*

380 Orange Street, Temple Mishkan Israel, March 2007. *Photograph by Colin M. Caplan.*

## K1. 380 Orange Street, Temple Mishkan Israel, 1896–97: Brunner & Tryon, New York

This Byzantine Revival–style synagogue is the oldest existing building in the city built for the Jewish community. The congregation was the first in the state, organized by German immigrants in 1840.

## K2. 385 Orange Street, Edward Russell House, 1886

This Queen Anne–style house was built for Mr. Russell, who operated Russell Brothers, New York Butter House on State Street.

## K3. 389 Orange Street, Eben Thompson House, 1856

This Italian Villa–style house was built for Mr. Thompson, a grocer on State Street.

## K4. 405–15 Orange Street, Smith & Sperry Row Houses, circa 1864.

Italianate style rows like this one were built in the area, many of them constructed by the prominent firm of Smith & Sperry.

## K5. 412 Orange Street, Samuel E. Merwin Jr. House, 1857

This Italian Villa–style house was built for Mr. Merwin, who ran a grocery store on State Street. He was adjutant general during the Civil War and was called to arrest a gang of one hundred ruffians from New York who prepared to hold a prize fight on Charles Island off Milford coast.

## K6. 37–39 Trumbull Street, Louis Berman Building, 1919–20: Brown & Von Beren

This Renaissance Revival–style apartment building is representative of a number of large residential buildings constructed in this area during the 1920s.

## K7. 431 Orange Street, Timothy Lester House, 1846

This dignified Italian Villa–style house, one of the first of this type in the city, was built for Mr. Lester, who worked at L.C. Candee & Co., boot manufacturer.

## K8. 445 Orange Street, William DeForest House, 1858–59

This Italian Villa–style house, originally covered with stucco, was built for Mr. DeForest, a physician.

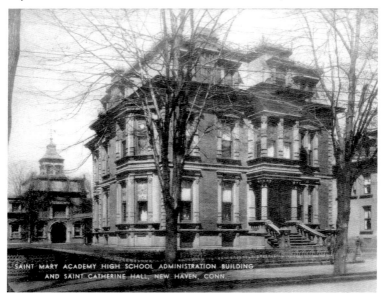

442 Orange Street, John C. Anderson House, circa 1915. *Courtesy of Joseph Taylor.*

### K9. 442 ORANGE STREET, JOHN C. ANDERSON HOUSE, 1882: JOHN KEELY, NEW YORK

One of the city's best examples of French Second Empire style, this mansion was built for Mr. Anderson, who inherited a fortune from his father's tobacco interests. The building eventually became part of St. Mary's Academy High School.

### K10. 466 ORANGE STREET, NEHEMIAH SPERRY HOUSE, 1857

This Italianate-style house was built for and by Mr. Sperry, who along with his bother Willis was a prominent builder under the firm Smith & Sperry.

### K11. 184 BRADLEY STREET, WILLIAM ALLING HOUSE, 1846

This Italian Villa–style cottage was built for Mr. Alling, a farmer, on a lot he purchased from Everard Benjamin.

### K12. 144–46 BRADLEY STREET, 1887

Double houses like this Queen Anne–style house were commonly built in this neighborhood during the 1880–90s.

### K13. 780 STATE STREET, JOHN B. WRIGHT BUILDING, 1890–91

This Italianate-style mixed-use building housed Mr. Wright's family member, O. Scott Wright, and his appliance store and plumbing company in 1891.

**K14. 790 STATE STREET, ST. STANISLAUS ROMAN CATHOLIC CHURCH, 1912–13: CHICKERING & O'CONNELL, BOSTON**
Polish immigrants founded this church in the late 1890s and named it in 1901. They were able to build their first church here, designed in Romanesque Revival style. The school next door was built in 1923.

**K15. 15 ELD STREET, ST. STANISLAUS CONVENT, 1923**
St. Stanislaus built this convent in 1923 in a similar Romanesque Revival style as their church.

**K16. 21 ELD STREET, GEORGE TOMLINSON HOUSE, 1854**
This Italian Villa–style house was built for and by Mr. Tomlinson, a mason builder.

**K17. 22 ELD STREET, GEORGE P. MERWIN HOUSE, 1857**
This Italianate-style house was built by and for Mr. Merwin, who was a partner in Hubbell & Merwin, builders.

**K18. 26 ELD STREET, CIRCA 1850**
This is an exemplary Greek Revival–style house, assuming the details are from a historic design.

**K19. 478 ORANGE STREET, FREDERICK IVES HOUSE, 1866**
This Italian Villa–style house was built for Mr. Ives, partner of Ives & Miller, axle manufacturers.

**K20. 484 ORANGE STREET, WATSON COE HOUSE, 1867–68**
The amount of Italian Villa–style houses like this one show this style's popularity during this period.

**K21. 495 ORANGE STREET, ENOS S. KIMBERLY HOUSE, 1884: RUFUS G. RUSSELL**
This Queen Anne–style house was built for Mr. Kimberly on the site of an earlier house that was likely moved away somewhere else.

**K22. 81–85 PEARL STREET, HENRY ELSON HOUSES, 1891**
Small rows of brick houses were built along the side streets in this area. This Queen Anne–style row was built for Mr. Elson, vice-president of the Bigelow Boiler Company.

**K23. 74–78 PEARL STREET, HENRY ELSON HOUSES, 1887–88**
Another Queen Anne–style row built by Mr. Elson; this one replaced his own house.

**K24. 26–32 PEARL STREET, CIRCA 1875**
This Italianate-style row provides a comforting street wall to this cozy street.

**K25. 14 Pearl Street, David Corey House, 1874–75**

Built for Mr. Corey, partner of Corey, Moore & Co., iron smelters, this is one of the most handsome Italianate-style town houses in the neighborhood.

**K26. 855 State Street, Swedish Evangelist Lutheran Church, 1904–05: Brown & Von Beren**

This Gothic Revival-style church was built for this Swedish parish.

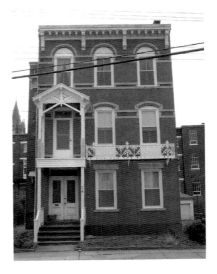

14 Pearl Street, David Corey House, March 2007. *Photograph by Colin M. Caplan.*

**K27. 11–17 Clark Street, Charles H. Webb Row Houses, 1872**

This Renaissance Revival-style row was built for Charles Webb, who developed the site as a real estate speculator.

**K28. 19 Clark Street, 1879–85**

Small Victorian-style cottages like this are unusual in this area. This one may have started off as a carpenter's shop.

**K29. 61–65 Clark Street, Benjamin Hague House, circa 1868–69**

This Italianate-style double house was built by and for Mr. Hague, a joiner.

**K30. 75 Clark Street, Samuel N. Judd House, 1868**

Unusual in proportions, this boxy Italianate-style house was built for and by Mr. Judd, a builder.

**K31. 545–51 Orange Street, Nelson Newgeon Houses, 1869–69**

Mr. Newgeon, a builder, constructed this row of lavish French Second Empire-style houses.

**K32. 548 Orange Street, the Belnord Apartment Building, 1915: Jacob Weinstein**

This large apartment building was designed with Mission-style elements.

Tour L.

# Saint Ronan Street and East Rock Neighborhoods

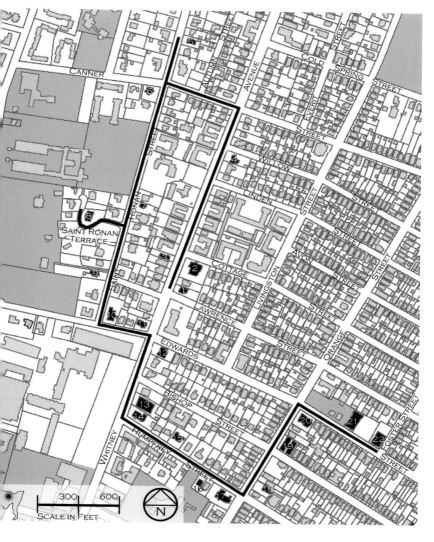

Saint Ronan Street and East Rock neighborhoods walking tour map.
*Compiled by Colin M. Caplan.*

**L1. 357 Whitney Avenue, Lemuel G. Hoadley House, 1897: William Allen**
This Queen Anne–style mansion was built for Mr. Hoadley, a real estate broker.

**L2. 389 Whitney Avenue, Charles S. Mellon House, 1893**
This Queen Anne–style mansion was built for Mr. Mellon, president of the New York, New Haven & Hartford Railroad.

**L3. 388 Whitney Avenue, George B. Stevens House, circa 1888**
This Queen Anne–style house was built for Mr. Stevens, a professor at Yale.

**L4. 475 Whitney Avenue, Colin M. Ingersoll House, 1896: Joseph W. Northrop, Bridgeport**
Perhaps the city's most striking residence, this Chateauesque-style mansion was built for Mr. Ingersoll, the chief engineer of the New York, New Haven & Hartford Railroad.

475 Whitney Avenue, Colin M. Ingersoll House, March 2007. *Photograph by Colin M. Caplan.*

**L5. 389 Saint Ronan Street, Reverend John C. Collins House, 1889**
This Shingle-style house was built for Reverend Collins, pastor of the Christian Workers of USA and Canada, and it was later home to Ms. Augusta "Gussie" Lewis Troup, a pioneer women's suffragist and founder of the Women's Typographical Union No. 1.

**L6. 346 Saint Ronan Street, William A. Warner House, 1909: Brown & Von Beren**
This Colonial Revival–style house was built for Mr. Warner, partner of the Warner-Miller Co., mason suppliers.

**L7. 257 Saint Ronan Street, Reverend John C. Collins House, 1886**
This Queen Anne–style house was built for Reverend Collins, who soon after moved up the street.

**L8. 5 Saint Ronan Terrace, Charles H. Webb House, 1904**
This Tudor Revival–style mansion was built for Mr. Webb, who developed this street in 1894. In 1912, the house became the dormitory for the Gateway School for Girls.

**L9. 208 Saint Ronan Street, Esther Porter House, 1884–85**
This Queen Anne–style house was built for Ms. Porter, widow of
Horace Porter. In 1914, Paul Benedict lived here and experimented
with using the house's tower for radio transmissions.

**L10. 309 Edwards Street, Henry Bradley House, 1905: Allen
& Williams**
This Georgian Colonial Revival–style house was built for Mr. Bradley,
head of Edward M. Bradley & Co., bankers and brokers, one of the
first firms in the country to finance utility companies.

**L11. 332–34 Whitney Avenue, Williston Walker House, 1901:
Edward T. Hapgood, Hartford**
This Colonial Revival–style house was built for Professor Walker, a
professor of ecclesiastical history at Yale. The house was also home to
both U.S. Presidents George H.W. and George W. Bush.

**L12. 321 Whitney Avenue, Atwater-Ciampolini House, 1890:
Babb, Cook & Willard, New York**
The best example of Shingle style in city, this house was built for
Charles E. and Helen G. Atwater.

**L13. 285 Whitney Avenue, Masonic Temple, 1926–27: Norton &
Townsend**
The Masons built this large Colonial Revival–style building to act as
an assembly hall.

**L14. 271 Whitney Avenue, Augustus H. Kimberly House, 1891:
Leoni Robinson**
This Queen Anne–style house was built for Mr. Kimberly, head of the
Stoddard, Kimberly & Co. wholesale grocer.

**L15. 445 Humphrey Street, Frederick J. Kingsbury Jr. House,
1901: Cram, Goodhue & Ferguson, Boston**
This Tudor Revival–style house was built for Mr. Kingsbury, who was
involved with real estate.

**L16. 412 Humphrey Street, Charles S. DeForest House, circa
1900**
This unusual Shingle-style house was built for Mr. DeForest, president
and secretary of the DeForest & Hotchkiss Lumber Co.

**L17. 574 Orange Street, St. John Episcopal Church, 1895: W.
Halsey Wood, New York**
The English countryside seems to have arrived on Orange Street when
you look at this Gothic-style church.

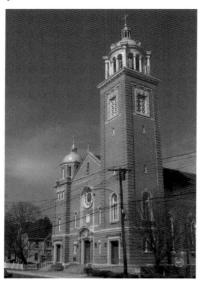

129 Edwards Street, St. Joseph's Roman Catholic Church, March 2007. *Photograph by Colin M. Caplan.*

## L18. 591 Orange Street, George Alling House, 1854–55

This Italian Villa–style house was built for Mr. Alling, who partnered with his brother Thomas in a lumber business. In 1856, Mr. Alling pursued business in Iowa for four years before returning to New Haven.

## L19. 625 Orange Street, Knickerbocker Apartments, 1919: Jacob Weinstein

When built, this large Renaissance Revival–style apartment building must have shocked the smaller-scaled neighborhood.

## L20. 655 Orange Street, Epworth Methodist Episcopal Church, 1892

Way before being absorbed into the First Methodist Church on Elm Street, this congregation built this Romanesque Revival–style church.

## L21. 129 Edwards Street, St. Joseph's Roman Catholic Church, 1904: Joseph A. Jackson, New York

An imposing Renaissance Revival–style church, St. Joe's was built by an Italian immigrant community.

## L22. 93 Edwards Street, Edwards Street School, 1870 and 1883: David R. Brown; 1922: Brown & Von Beren

This is one of the earliest school buildings existing in the city. The Gothic Revival building was raised one story in 1883, and the entrance addition was added in 1922.

# Tour M.

# *Beaver Hills Neighborhood*

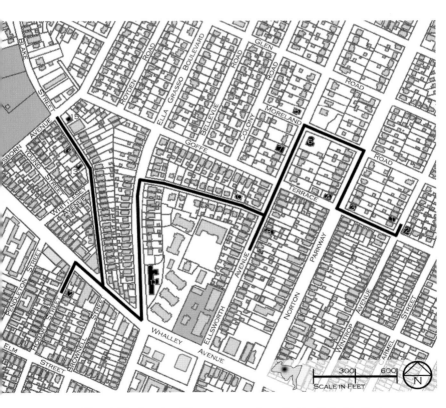

Beaver Hills neighborhood walking tour map. *Compiled by Colin M. Caplan.*

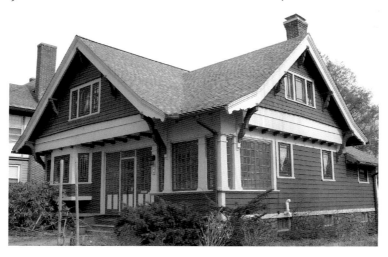

389 Norton Parkway, Charles M. Dobbs House, March 2007. *Photograph by Colin M. Caplan.*

### M1. 596 WINTHROP AVENUE, WILLIAM A. COLEMAN HOUSE, 1908–09: FOOTE & TOWNSEND

This Bungalow-style house was built for Mr. Coleman, president and treasurer of the City Hall Pharmacy. The house was built by the Beaver Hills Company, which developed a large tract in this area.

### M2. 591 WINTHROP AVENUE, BEAVER HILLS TENNIS CLUBHOUSE, 1913; FOOTE & TOWNSEND

The Beaver Hills Company was the first developed neighborhood in the city that offered activities like tennis, for which this Bungalow-style clubhouse was built. In 1926, there were more than two hundred members from across the city.

### M3. 389 NORTON PARKWAY, CHARLES M. DOBBS HOUSE, 1910: FOOTE & TOWNSEND

This Bungalow-style house was built for Mr. Dobbs, the secretary and treasurer of the Monarch Laundry Company.

### M4. 390 NORTON PARKWAY, BEAVER HILLS COMPANY HOUSE, 1908; FOOTE & TOWNSEND

This Bungalow-style house was the first house built on the development tract, even prior to the construction of the street through this block. The Mead family organized the Beaver Hills Company and it was one of the first planned residential neighborhoods in the country built for automobile access.

**M5. 488 Ellsworth Avenue, Alexander C. Middleton House, 1913: Charles F. Townsend**
This Tudor Revival–style house was built by the Beaver Hills Company for Mr. Middleton, a foreman at the General Electric Company.

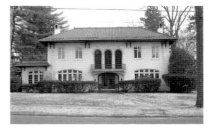

475 Ellsworth Avenue, Alfred H. Powell House, March 2007. *Photograph by Colin M. Caplan.*

**M6. 475 Ellsworth Avenue, Alfred H. Powell House, 1921: Roy W. Foote**
This Spanish Colonial Mission–style house, the most dignified in the city, was built for Mr. Powell, president and treasurer of A.H. Powell & Co., wholesale coal dealers.

**M7. 460 Ellsworth Avenue, Frank E. Edgar House, 1912**
This rustic Bungalow-style house was built by the Beaver Hills Company for Mr. Edgar, a commercial travel agent.

**M8. 409 Ellsworth Avenue, Vito Zichichi Development House, 1920**
This intricately ornamented Colonial Revival–style multi-family flat was built by Mr. Zichichi, a builder and real estate developer.

**M9. 391 Ellsworth Avenue, Hartog-Walker House, 1889–90**
This small Queen Anne–style house was built as a speculative real estate venture for Ferdinand Hartog and later sold to George K. Walker, a clerk at the Winchester Repeating Arms Company.

**M10. 35 Anita Street, Phillip Sellers House, 1925: Phillip Sellers**
This Prairie-style house was built for Mr. Sellers, a prominent local architect.

**M11. 1495–99 Ella Grasso Boulevard, Broadmoor Apartments, 1928**
Apartment buildings like this were rarely built in this section of the city. This one was designed in the Tudor Revival style.

**M12. 133–35 Hobart Street, John Lines House, 1865–67; 1911**
One of the most extravagant Gothic Revival– and Stick-style houses existing in the city, it was built for Mr. Lines around the corner on Whalley Avenue, but was moved here in 1911 to make room for multi-family flats by the contractor, Albert W. Penney.

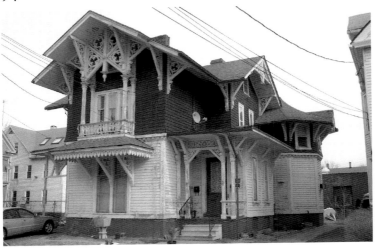

133–35 Hobart Street, John Lines House, March 2007. *Photograph by Colin M. Caplan.*

### M13. 96 BLAKE STREET, DEACON JOHN WHITE JR./THOMAS BILLS HOUSE, CIRCA 1750; CIRCA 1795; CIRCA 1805; CIRCA 1850; 1922

Captain John White sold this Colonial house to his son, Deacon John Jr., in 1752, and in 1760 it became home to Thomas Bills, a highly respected civic leader and one of the master masons involved in constructing Yale's oldest existing building, Connecticut Hall. The house has been added to and remodeled a number of times over the years.

### M14. 114 BLAKE STREET, MARCUS SHUMWAY HOUSE, CIRCA 1870; 1911

This pristine French Second Empire house was built for Mr. Shumway, a molder and superintendent of the Blake Brothers Manufacturing Co. once located a few blocks down the street. Mr. Shumway was also one of the founders of the Westville Methodist Church. In 1911, the house was moved to the front of the lot.

### M15. 129 BLAKE STREET, PETER MAVERICK/ LEAVERETT BRADLEY HOUSE, CIRCA 1797

This Federal-style house was built for Peter Maverick and in the 1830s–40s it was remodeled with Greek Revival–style elements by Mr. Bradley. Marcus Shumway and his family lived in this house starting in 1836.

Tour N.

# *Westville Neighborhood Center*

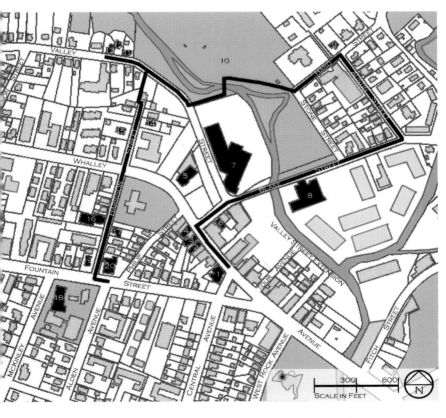

Westville neighborhood center walking tour map. *Compiled by Colin M. Caplan.*

### N1. 882–88 Whalley Avenue, Hotel Edgewood, circa 1830; circa 1890; 1913: Charles E. Joy

This Colonial Revival–style building is actually two buildings, a part of which was built here as a house around 1830. Attached to the left-hand side of the house around 1890 was a building called Franklin Hall, which was previously a middle school moved from Harrison Street to Fountain Street around 1878. In 1913, the buildings were unified with one roof and additions were added.

### N2. 904–06 Whalley Avenue, Knights of Pythias Hall, circa 1887

This Queen Anne–style building was built for Harriet Sperry, who lived next door. The Knights of Pythias used the building for their assembly hall.

### N3. 908–12 Whalley Avenue, James Thompson Jr. House, circa 1750

This Colonial-era house, probably the oldest in Westville, passed through many owners, including Alfred C. and Harriet Sperry in 1847. The Sperrys lived here and ran a store in the front.

### N4. 914–18 Whalley Avenue, Hotchkiss-Alling House, circa 1795

This Federal-era house was built by the Hotchkiss family, whose relative Sheriff Joshua Hotchkiss was the area's first known resident in 1658. In 1822, Lyman Alling purchased the house and his relative, Claudius Alling, ran a butcher shop here.

### N5. 949 Whalley Avenue, Masonic Temple, 1926: Roy W. Foote

This Colonial Revival–style building was used as an assembly hall for the local Masonic lodge.

### N6. 512 Blake Street, James G. Hotchkiss House, circa 1840; 1926

This Greek Revival–style house was built for Mr. Hotchkiss, a match maker at the Diamond Match Company down the street. Originally built at the corner, the house was moved here when the Masonic temple was built in 1926.

### N7. 495 Blake Street, Geometric Tool Company Building, 1906: Brown & Von Beren; 1912; 1915

Built on the site of mills dating from the Colonial period, the Geometric Tool Company built tool and drill parts.

### N8. 446 Blake Street, Greist Manufacturing Company Building, 1906: Brown & Von Beren; 1910: Philip Sellers

John Milton Greist started selling sewing machines with his mother and founded this company in 1871. The company moved into a plant

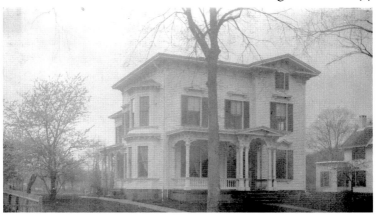

88 Harrison Street, Noyes Perkins House, circa 1910. *Courtesy of Joseph Taylor.*

here in 1892 and became the world's largest producer of sewing machine attachments.

### N9. 36 Hard Street, Henry Ives House, 1851–54
This Greek Revival–style house was built for Mr. Ives on land he purchased from Leaverett Thomas.

### N10. West Rock Park, 1826; 1891
Now the second largest state park, part of this traprock ridge was donated to the city by Westville resident Elijah Thompson in 1826. The remainder was slowly acquired starting in 1891, when the park was established. On top of the rock are a group of boulders that hid three regicide judges who condemned King Charles I.

### N11. 105–07 Valley Street, Elijah Thompson House, circa 1787
This Federal-era house was built for Mr. Thompson, a Revolutionary War hero who helped build a powder mill behind this house during the war. The large sycamore tree in the rear yard of the house next door was mentioned as a boundary in the 1787 deed.

### N12. 115 Valley Street, Bradley-Warner House, 1843; 2004
This Greek Revival–style house was built by Sherman Warner, a joiner, for Lydia Bradley. From 1948 to 1951, it was home to Ethan Allen, professional baseball player, Yale coach and founder of All-Star baseball. The house was saved from demolition and moved here in 2004.

### N13. 119 Valley Street, Albert Mallory House, circa 1775
Although this Colonial-era house was built for Captain Joseph Mix, it was occupied by Mr. Mallory, who operated a paper mill on the river behind the house.

34 Harrison Street, Westville
Congregational Church, circa 1910.
*Courtesy of Joseph Taylor.*

**N14. 97 HARRISON STREET, H. DAYTON STANNARD HOUSE, 1893**
This Queen Anne–style house was built for Mr. Stannard, an employee at the Diamond Match Company on Valley and Blake Streets.

**N15. 88 HARRISON STREET, NOYES PERKINS HOUSE, 1875**
This Italianate-style house was built for Mr. Perkins, a government official who never lived here but resided in the West Indies.

**N16. 34 HARRISON STREET, WESTVILLE CONGREGATIONAL CHURCH, 1835–36**
This Greek Revival–style church was influenced by the work of Minard Lafever, who helped popularize this style in the United States. Prior to the church's construction, its congregants had to make the trek down to the Green for Sunday church services.

**N17. 27 HARRISON STREET, LEVERETT HEMINGWAY HOUSE, 1879–85**
This Italianate-style house was built for Mr. Hemingway, owner of the Valley Farm Creamery.

**N18. 112–24 FOUNTAIN STREET, ST. AIDAN'S ROMAN CATHOLIC CHURCH, 1921–22; 1930–31**
This Gothic Revival–style church started here as St. Joseph's Church. The present church was built in 1921–22, while the rectory was built in 1930–31.

**N19. 105–09 FOUNTAIN STREET, FIREHOUSE, 1915: BROWN & VON BEREN**
This small Colonial Revival–style firehouse is almost identical to ones built on both Lighthouse Road and on East Grand Avenue (see R23).

**N20. 95 FOUNTAIN STREET, POST OFFICE, 1937**
Along with the park, library, churches and synagogues, school and firehouse, this Colonial Revival–style building completes the feeling of a small town.

Tour O.

# *Westville Neighborhood Streetcar Suburb*

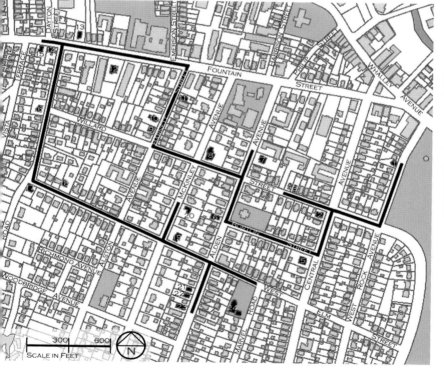

Westville neighborhood streetcar suburb walking tour map. *Compiled by Colin M. Caplan.*

500 Central Avenue, Charles A. Marvin House, March 2007. *Photograph by Colin M. Caplan.*

## O1. 352 WEST ROCK AVENUE, ELIJAH THOMPSON HOUSE, PRE-1822; 1840S

This Greek Revival–style house was home to Morris Isbell and Sheldon Hotchkiss, both local manufacturers.

## O2. 27 WILLARD STREET, EAST DISTRICT SCHOOLHOUSE, CIRCA 1830; 1872

This French Second Empire house was originally Westville's East District School, located on the corner of Fitch and Blake Streets. In 1872, Theodore F. Shumway moved it here, remodeling it into a residence.

## O3. 31 WILLARD STREET, EMILY E. RAMSDELL HOUSE, 1870–74

This Gothic Revival–style cottage was either moved or built here between 1870–74.

## O4. 538 CENTRAL AVENUE, BROWNELL SKILTON HOUSE, CIRCA 1830; CIRCA 1888

This Italianate-style house was built for Deacon Henry Murray around 1830 on Fountain Street. It was moved here and renovated around 1888 to make way for another house.

## O5. 500 CENTRAL AVENUE, CHARLES A. MARVIN HOUSE, 1899: WILLIAM H. ALLEN

This extravagantly ornamented Queen Anne–style mansion was built for Mr. Marvin, who ran Tayor & Marvin Grocers on Whalley Avenue in the village.

272 Fountain Street, Bradley-Dickerman House, circa 1905. *Courtesy of the New Haven Museum and Historical Society.*

### O6. 280 ALDEN AVENUE, WOODRUFF-ROBERTSON HOUSE, 1870–74

This Italianate- and Stick-style house was built for Mary E. Woodruff, and after her death in 1884 it was sold to Thomas B. Robinson, a marble and granite worker for burial stones at the Westville Cemetery.

### O7. 329 ALDEN AVENUE, FREDERICK PENNY HOUSE, 1899

This Queen Anne– and Renaissance Revival–style house was built for Mr. Penny, a commercial travel agent.

### O8. 325 MCKINLEY AVENUE, PERCY RAYMOND GREIST HOUSE, 1898–99: BROWN & VON BEREN

This large Colonial Revival–style house was built for Mr. Greist, the president and general manager of the Greist Manufacturing Co. on Blake Street.

### O9. 72 BARNETT STREET, WILLIS DICKERMAN HOUSE, CIRCA 1830; CIRCA 1865

This Gothic Revival–style house was built as a cooper shop for Mr. Dickerman. It was originally located on Forest Road, but the building was moved here and converted to a residence around 1865.

### O10. 80 BARNETT STREET, WILLIAM HARTLEY HOUSE, 1861–62

This Italianate-style house was built for Mr. Hartley, a civil engineer and surveyor.

### O11. 101 BARNETT STREET, ROBERT VEITCH JR. HOUSE, CIRCA 1871

This Gothic Revival–style house was built for Mr. Veitch, a florist.

300 West Elm Street, Deacon Isaac Dickerman House, circa 1880. *Courtesy of the New Haven Museum and Historical Society.*

### O12. 216 FOUNTAIN STREET, LOUIS G. MINER HOUSE, 1910: ALLEN & WILLIAMS

This Bungalow-style house was built for Louis G. Miner, head of the New Era Lustre Company, a lacquer manufacturer.

### O13. 243–45 FOUNTAIN STREET, BURTON AND FRANK STOWE HOUSE, CIRCA 1898

This Queen Anne–style house was built for the Stowe family, mason builders.

### O14. 264–66 FOUNTAIN STREET, BRADLEY-DICKERMAN HOUSE, CIRCA 1770; CIRCA 1800

This Federal-era house was likely built for Phineas Bradley. In 1805, it became home to Isaac Dickerman Jr., who lived here until 1826, when he moved next door.

### O15. 272 FOUNTAIN STREET, BRADLEY-DICKERMAN HOUSE, CIRCA 1800

This Federal-era home may have been built as a shop for Phineas Bradley. In 1826, Isaac Dickerman Jr. moved here from next door, and lived here until his death in 1835.

### O16. 1244 FOREST ROAD, GLOVER BALL HOUSE, CIRCA 1720; 1805; CIRCA 1920

This Colonial-style house was either built by John Ball or by his grandson, Glover, in 1805. The house was altered at some point by the exterior application of stucco.

**O17. 300 West Elm Street, Deacon Isaac Dickerman Jr. House, circa 1779**
This Colonial-era house was built by Mr. Dickerman, who defended the town during the British invasion in 1779 and was a farmer, cooper and deacon of the United Church on the Green. Mr. Dickerman married Glover Ball's daughter, Hannah, in 1781.

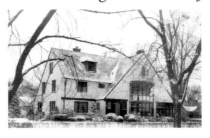

255 McKinley Avenue, Abraham Notkins House, circa 1945. *Courtesy of Colin M. Caplan.*

**O18. 275 West Elm Street, Lesley E. Forsyth House, 1917–18: Shiner & Appel**
This Tudor Revival–style house with a false thatch roof was built for Mr. Forsyth, treasurer of the Forsyth Dyeing Co. located at the corner of Whalley Avenue and Fitch Street.

**O19. 255 McKinley Avenue, Abraham Notkins House, 1921: Brown & Von Beren**
This Tudor Revival–style house was built for Mr. Notkins, head of A.L. Notkins & Sons, real estate and insurance agents.

**O20. 277 McKinley Avenue, R.W. Hanna House, 1912: Shiner & Appel**
This is an unusual Tudor Revival–style house for the area, and the house is an example of the pleasures of a simple design.

**O21. 206–08 Alden Avenue, Harry McCaulley House, 1913**
This Colonial Revival–style three-family flat was built for Mr. McCaulley, a building contractor.

**O22. 218 Alden Avenue, Mitchell-Hall House, circa 1895**
This Queen Anne–style house was built for Robert F. Mitchell as a speculative real estate venture and then sold in 1910 to Fred J. Hall, a commercial travel agent.

**O23. 222 Alden Avenue, Mitchell-Bowman House, circa 1895**
This Queen Anne–style house was built for Robert F. Mitchell as a speculative real estate venture and then sold in 1914 to Charles H. Bowman, vice-president of the Gilbert Manufacturing Co., corset manufacturers.

**O24. 110 Marvel Road, Church of St. James the Apostle, 1922–23; 1926**
This Gothic-style church was built for this Episcopal congregation. The Tudor-style rectory was constructed in 1926.

# Tour P.

# *Westville's Edgewood Neighborhood*

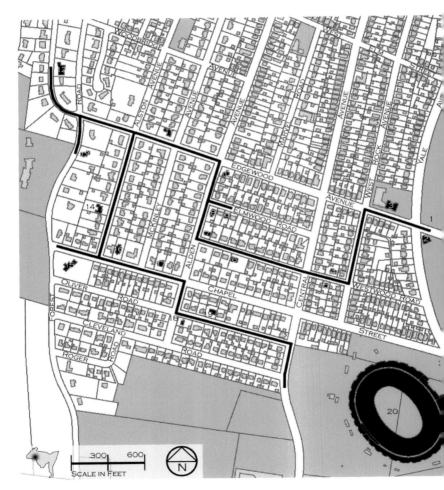

Westville's Edgewood neighborhood walking tour map. *Compiled by Colin M. Caplan.*

**P1. Edgewood Park, 1889, Donald Grant Mitchell and Frederick Law Olmsted Jr.**

The park was created by Mr. Mitchell, a prolific author during the mid- to late nineteenth century, and Mr. Olmsted, son of the designer of New York City's Central Park. The park's name is derived from Mr. Mitchell's adjacent farm, which he named Edgewood. The West River that runs through the center of the park was straightened, creating curious, murky oxbow ponds.

**P2. 720 Edgewood Avenue, Police Station 6, 1922: Brown & Von Beren**

This Tudor-style building was built in response to this area's residential boom.

**P3. 737 Edgewood Avenue, Edgewood School, 1911: Brown & Von Beren**

This Colonial Revival–style school building was built by the Westville School District prior to its merge into New Haven's school district.

**P4. 75 Westwood Road, Robert E. Peck House, 1912**

This Colonial Revival–style house was built for Mr. Peck, a physician.

**P5. 86 Westwood Road, Albert D. deBussy House, 1916: Frank Elmwood Brown**

This Colonial Revival–style house was built for Mr. deBussy, who was involved with the Edgewood Development Co., the developer of the surrounding neighborhood.

**P6. 162 Westwood Road, William M. Hotchkiss House, 1914–15**

This Tudor Revival–style house was built for Mr. Hotchkiss, a real estate and insurance agent.

**P7. 189 Westwood Road, Mildred M. Rice House, 1922**

This exquisitely ornamented Tudor Revival–style house was built for Ms. Rice, head of the Herbert & Rice, Inc., real estate agents. Ms. Rice was also associated with the F. Mansfield & Co., oyster growers.

**P8. 86 Elmwood Road, Frances S. Hamilton House, 1927: Alice Washburn**

This Colonial Revival–style house was built for Mr. Hamilton, head of F.S. Hamilton, insurance agents. The design was by Ms. Washburn, one of the only self-taught female architects in the country at that time.

2107 Chapel Street, Samuel Batter House, March 2007. *Photograph by Colin M. Caplan.*

131 Oliver Road, Oliver Smith House, March 2007. *Photograph by Colin M. Caplan.*

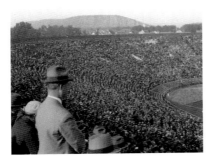

Yale Bowl, October 25, 1924. *Photograph by the Keystone View Company. Courtesy of Colin M. Caplan.*

### P9. 66 ELMWOOD ROAD, JOSEPH C. LIPPENCOTT HOUSE, 1911–12: PHILLIP SELLERS

This Craftsman-style house was built for Mr. Lippencott, secretary and treasurer of the Old Elms Pottery Company.

### P10. 105 ALDEN AVENUE, RUSSELL VON BEREN HOUSE, 1922: BROWN & VON BEREN

This false thatch roof Tudor-style house was designed for the architect's brother, who was head of the National Construction Company as well as Von Beren Realty Co.

### P11. 116 MCKINLEY AVENUE, FERDINAND VON BEREN HOUSE, 1913: BROWN & VON BEREN

Mr. Von Beren, a German immigrant, designed this Colonial Revival–style house for his family. He was one of the city's most prolific architects, designing most of the city's schools, police and fire stations and countless other buildings.

### P12. 49 EDGEWOOD WAY, EDGEWOOD, CIRCA 1870: DONALD GRANT MITCHELL AND DAVID R. BROWN

Mr. Mitchell, a prolific nineteenth-century author with the pen name Ik Marvel, purchased a huge estate here in 1858. He helped design this Stick-style mansion, as well as the layout for his estate.

### P13. 999 FOREST ROAD, EDGEWOOD FARMHOUSE, CIRCA 1860: DONALD GRANT MITCHELL AND DAVID R. BROWN

This Stick-style house was built for Mr. Mitchell's daughter, Susan. The house was later enlarged and altered.

**P14. 40 ALSTON STREET, MACK L. KANDER HOUSE, 1929–30**
This unusual Mission-style house was built for Mr. Kander, who was employed at the Sterling Finance Corporation.

**P15. 2150 CHAPEL STREET, LESLIE H. JOCKMUS HOUSE, 1935: BROWN & VON BEREN**
One of the most impressive Tudor Revival-style mansions in the city, this house was built for Mr. Jockmus, a novelty manufacturer.

**P16. 2107 CHAPEL STREET, SAMUEL BATTER HOUSE, 1928–29**
Perhaps the city's most exotic house, it was designed in the Prairie style with influences of Frank Lloyd Wright. Mr. Batter utilized the tile materials from his company, the Batter Building Materials Company.

**P17. 2073 CHAPEL STREET, ISRAEL J. HOFFMAN HOUSE, 1925**
This Colonial Revival-style house was built for Mr. Hoffman, a partner with Hoffman and Hoffman, lawyers.

**P18. 11 ALDEN AVENUE, CLAYTON WOODWARD HOUSE, 1925: ALICE WASHBURN**
This Colonial Revival-style house was built for Mr. Woodward, the assistant general manager of the New York, New Haven & Hartford Railroad office building.

**P19. 131 OLIVER ROAD, OLIVER SMITH HOUSE, CIRCA 1840**
This elegant Greek Revival-style house was built for Mr. Smith, whose family owned and farmed the surrounding fields.

**P20. 249 DERBY AVENUE, YALE BOWL, 1913–14: CHARLES A. FERRY**
This structure was the largest arena built since the Roman Coliseum, seating over seventy thousand people. The structure is built into the ground with a ring of earth covered with concrete. Although Mr. Ferry designed and engineered this massive project, he used Yale graduate Don Barber as the consulting architect.

Tour Q.

# Fair Haven's Dragon Neighborhood

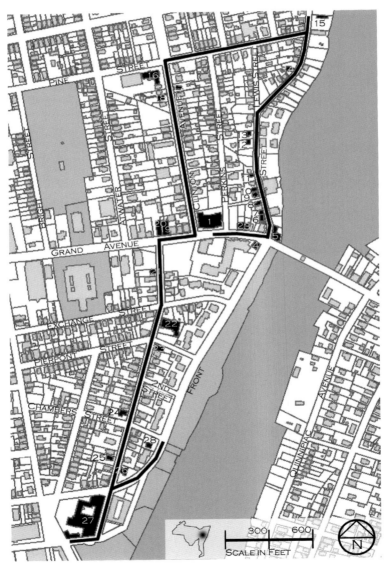

Fair Haven's Dragon neighborhood walking tour map. *Compiled by Colin M. Caplan.*

### Q1. 69 GRAND AVENUE, HORACE H. STRONG SCHOOL, 1915: BROWN & VON BEREN

The land on this block was deeded to the people of Fair Haven in 1808 to be used for a public purpose. This Jacobethan Revival–style school was named for Mr. Strong, organizer of one of the largest produce houses in the state.

### Q2. 37–39 GRAND AVENUE, ELBERT MUNSELL HOUSE, 1834

This Greek Revival–style double house was built by Mr. Munsell, a builder, for Elijah Rowe. Rowe then sold Mr. Munsell the left side of the house to live in.

### Q3. 33 GRAND AVENUE, JAMES BROUGHTON HOUSE, 1846

This Greek Revival–style house was built for Mr. Broughton, an oyster can manufacturer.

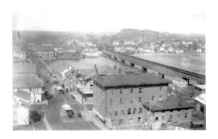

### Q4. 14 GRAND AVENUE, KING'S BLOCK, 1820S; CIRCA 1850

View looking over the Quinnipiac River at Grand Avenue, taken from Pilgrim Church, circa 1890. *Courtesy of Joseph Taylor.*

Perhaps one of the earliest commercial buildings in the city, this Federal-style building was built as a hotel by one of Fair Haven's earliest residents, Herman Hotchkiss. Around 1850, Daniel M. King purchased the building and added two additions.

### Q5. 1–7 GRAND AVENUE, ROLAND T. WARNER COMPANY BUILDING, CIRCA 1885

This Italianate-style commercial block was built for the Roland T. Warner Co., hardware store. This area was called Dragon, a name given to the seals that frequently sunned themselves on the shore of the Quinnipiac River.

### Q6. 182–84 FRONT STREET, STEPHEN ROWE HOUSE AND TAVERN, CIRCA 1788; 1804; 1859

This Federal-era house was built by Mr. Rowe, a West Indian trade merchant who later operated a popular tavern in the house. The house may have been remodeled in 1804, and was moved here from the corner of Grand Avenue in 1859.

### Q7. 186 FRONT STREET, ISAAC MALLORY HOUSE, 1839

This Greek Revival–style house was built for Mr. Mallory, a confectioner.

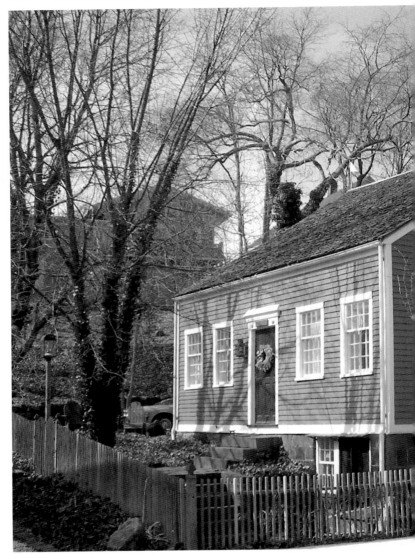

196–98 Front Street, Thomas Alling House, March 2007. *Photograph by Colin M. Caplan.*

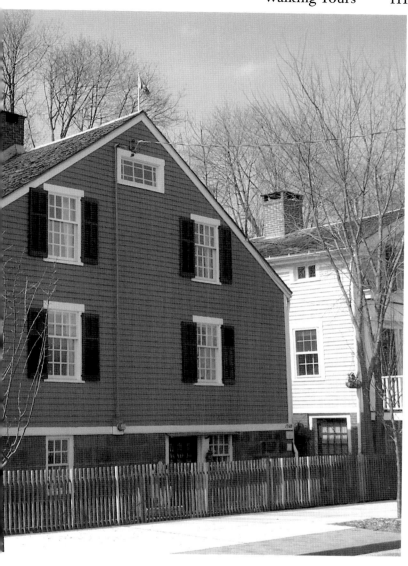

**Q8. 192 FRONT STREET, ALFRED MALLORY HOUSE, 1844**
This Greek Revival-style house was built for Mr. Mallory, and after his death it was occupied by his widow.

**Q9. 196–98 FRONT STREET, THOMAS ALLING HOUSE, CIRCA 1760 OR CIRCA 1790; CIRCA 1835**
This Colonial-era Cape-style house was likely built by Mr. Alling. Half of the house was renovated around 1835.

**Q10. 200–02 FRONT STREET, LEVI GRANNISS JR. HOUSE, 1847**
This Greek Revival-style house was built for Mr. Granniss, an oysterman.

**Q11. 208 FRONT STREET, BENOMI GILLET JR. HOUSE, 1818–19**
This Greek Revival-style house was built for Mr. Gillet, an oysterman.

**Q12. 224 FRONT STREET, JESS BALL HOUSE, 1841**
This Greek Revival-style house was built for Mr. Ball, a mariner.

**Q13. 228 FRONT STREET, ZINA BALL HOUSE, 1844**
This Greek Revival-style house was built for Mr. Ball, an oysterman.

**Q14. 264 FRONT STREET, WILLIAM BROOKS HOUSE, CIRCA 1846**
This unusual Italian Villa-style house was built for Mr. Brooks, a shipwright and ship caulker.

**Q15. 289 FRONT STREET, NEW YORK CITY OYSTER BARGE, CIRCA 1875; 1921**
Originally built along the Hudson or East Rivers in New York City, this oyster barge was floated here in 1921 by Ernest E. Ball. He then converted it into a bar and named it the Ark Club.

**Q16. 118 CLINTON AVENUE, THE HOME FOR THE FRIENDLESS, 1888: HENRY AUSTIN; 1898**
The Home for the Friendless was begun in 1866 in a house on this site. The left wing of this building was added in 1888. In 1898, the main portion was built and named after the donor's sister, Mary Wade.

**Q17. 103 CLINTON AVENUE, CHANCELOR KINGSBURY HOUSE, 1835**
This Greek Revival-style house was built for and by Mr. Kingsbury, who developed the surrounding area.

**Q18. 98 CLINTON AVENUE, THOMAS G. SLOAN DEVELOPMENT HOUSE, 1881–82**
This Gothic Revival-style house was built by Elihu Watrous for Mr. Sloan, a real estate agent.

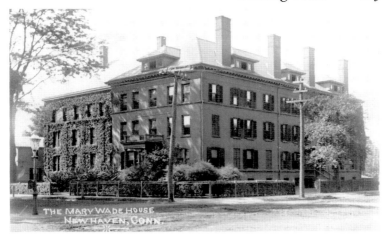

118 Clinton Avenue, the Home for the Friendless, circa 1910. *Courtesy of Joseph Taylor.*

### Q19. 93–99 GRAND AVENUE, BISHOP BUILDING, 1891
This Italianate-style block was built for Walter D. Bishop, an electric motor designer.

### Q20. 101–05 GRAND AVENUE, HENRY WARREN CRAWFORD COMPANY, 1865; 1896
This French Second Empire–style building was built for the Henry Warren Crawford Company, furniture makers and undertakers. The rear section of the building was added in 1896.

### Q21. 116 EAST PEARL STREET, FRANK M. CRAWFORD HOUSE, 1892–93
This Queen Anne–style house was built for Mr. Crawford, who worked at Henry Warren Crawford Company, his family's furniture and undertaking business on Grand Avenue.

### Q22. 95 EAST PEARL, EAST PEARL STREET METHODIST CHURCH, 1871–73 AND 1889: JOHN S. WELCH, NEW YORK
This congregation began in 1833, and after building two other churches they constructed this Gothic Revival–style building. The spire was finished in 1889.

### Q23. 87–89 EAST PEARL STREET, HENRY W. BROUGHTON HOUSE, 1847
This Italianate-style house was built by Elbert Munsell for Mr. Broughton, owner of Broughton and Clark, a hardware store on East Grand Avenue. The house was later remodeled from its original Greek Revival form.

## Q24. 58 EAST PEARL STREET, AI RUSSELL HOUSE, 1836

This Greek Revival–style house was built for Mr. Russell, a peddler.

## Q25. 42 EAST PEARL STREET, WILLIS S. BARNES HOUSE, CIRCA 1848

This unusual Italian Villa–style house was built for Mr. Barnes, a mariner and oyster dealer on Front Street.

## Q26. 37 EAST PEARL STREET, SAMUEL HEMMINGWAY HOUSE, 1840S; 1870S

This French Second Empire–style house was built for Isaac H. Foote, who ran coal yards and a schooner, the *H.R. Smith*. After his death, Foote's wife married Mr. Hemingway, account manager for local oyster dealers. The third floor was added in the 1870s.

## Q27. 21–23 RIVER STREET, QUINNIPIAC BREWING COMPANY, 1882; 1891; 1896: LEONI ROBINSON; 1906: OTTO C. WOLF, PHILADELPHIA

This Victorian- and Romanesque Revival–style brewery was built up over a number of years. The main façade was added in 1896, and a three-story addition was added in 1906.

## Q28. 22 FRONT STREET, CAPTAIN EDWIN THOMPSON HOUSE, CIRCA 1845

This stucco-covered Greek Revival–style house was built for Captain Thompson, a mariner and oyster dealer. The house was built on a high foundation, a shoreline tradition that provided the oyster harvesters and fishermen with an easy way to bring their catch home.

Tour R.

# *Fair Haven Heights Neighborhood*

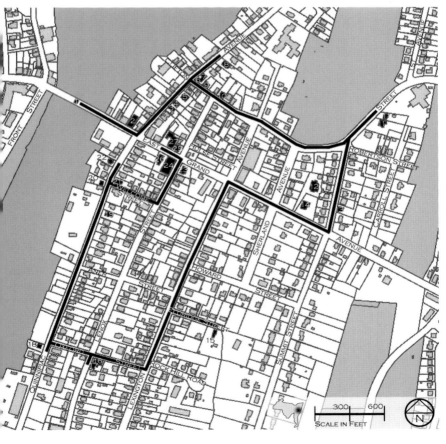

Fair Haven Heights neighborhood walking tour map. *Compiled by Colin M. Caplan.*

### R1. Dragon Bridge, 1896–98

This iron lift bridge was considered modern when it was built, and it was fitted with a classy little operator's house in the middle. The first bridge over the Quinnipiac River was built here in 1791–93, an alternative to the ferry just down the river.

### R2. 28–30 East Grand Avenue, Long Brick Store, circa 1829

This Greek Revival-style commercial block was built by Herman Hotchkiss, one of the earliest settlers in this area in 1788. The basement served as a local jail for a time in the mid-nineteenth century.

### R3. 701 Quinnipiac Avenue, Edwin D. Fowler House, 1845

This Greek Revival-style house was built for Mr. Fowler, a jeweler on East Grand Avenue.

### R4. 705 Quinnipiac Avenue, William Bradley House, 1835

This Greek Revival-style building was built for Mr. Bradley on farm land he purchased from Isaac Brown.

### R5. 715 Quinnipiac Avenue, Samuel Miles Brown House, 1765; 1856

This house was originally built in the Colonial style. It was remodeled in the Italianate style in 1856, when it became home to Mr. Brown, who operated a grocery store on the corner of East Grand Avenue.

### R6. 731 Quinnipiac Avenue, H. Rowe House, circa 1830

This robust Greek Revival-style house was built for Mr. Rowe, who was involved in his family's oyster harvesting business.

### R7. 735 Quinnipiac Avenue, R. Rowe House, circa 1830

Similar in treatment to its neighbor, this Greek Revival-style house was built for Mr. Rowe, who was involved with his family's oyster harvesting business.

### R8. 759 Quinnipiac Avenue, Willis Hemmingway House, 1849

This Italian Villa-style house was built for Mr. Hemingway, father of Samuel from East Pearl Street (see S26), and head of a popular dry goods store on East Grand Avenue.

### R9. 12 Clifton Street, Ezra Rowe House, 1774

This Colonial-style house was built for Mr. Rowe, whose father, John, owned much of the surrounding area. Mr. Rowe began one of the largest oyster businesses in the state.

### R10. 26 Clifton Street, Hiram Rowe House, 1845–51

This large Italianate style double house was built for Mr. Rowe, an oysterman who developed a number of properties in the area.

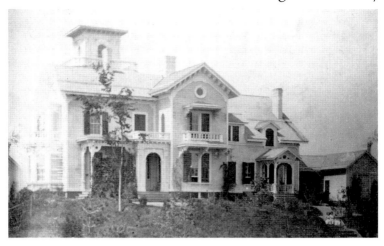

Clifton Street, Charles Ives House, circa 1865. *Courtesy of Joseph Taylor.*

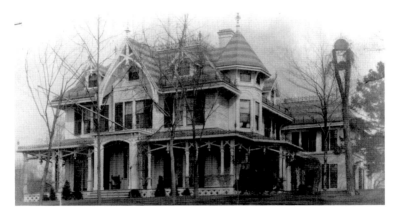

89 Sherland Avenue, James F. Babcock House, circa 1910. *Courtesy of Joseph Taylor.*

### R11. 151–53 AND 159–61 CLIFTON STREET, CHARLES IVES HOUSE, CIRCA 1860: RUFUS G. RUSSELL; 1923

One of the grand estates of the Heights, this Italianate-style house was built for Mr. Ives, a lawyer as well as a member of the state General Assembly and Speaker of the House. Originally the house was located in the park across the street, but it was moved and split in two in 1923.

### R12. 89 SHERLAND AVENUE, JAMES F. BABCOCK HOUSE, 1862

This Gothic Revival–style mansion was built for Mr. Babcock, lawyer and publisher of the *New Haven Palladium*. The estate originally

contained thirty acres, but it was sold off after 1869 by developer Samuel L. Blatchley after Mr. Babcock moved into lower Fair Haven.

### R13. 353 Summit Street, James F. Babcock Estate Carriage House, 1862

This Gothic-style carriage house was part of Mr. Babcock's estate.

### R14. 154 East Grand Avenue, Dr. Mary Blair Moody House, 1875

This Stick-style house was built for Dr. Moody, the first female doctor to practice in New Haven.

### R15. 11 Eldridge Street, Powder House, circa 1850

This Italianate-style house was built by the Hazardville Powder Company to store the gunpowder that they used to quarry these hills.

### R16. 167 Lenox Street, Linsley-Holaday House, 1847–51

This Victorian-style house was built for George W. Linsley and later sold in 1867 to Edward N. Holaday, a shipwright and caulker.

### R17. 171 Lenox Street, Lester Rowe House, 1873

This Italianate-style house was built for Mr. Rowe, a master builder of a kind of boat called a sharpie.

### R18. 490 Quinnipiac Avenue, Jessie Mallory House, circa 1810

This Federal-era house, the oldest known house in the vicinity, was built for Mr. Mallory on land he purchased from East Haven.

### R19. 603 Quinnipiac Avenue, Luzerne Ludington House, 1883

This Queen Anne–style house was built for Mr. Ludington, who worked with his family's business, C.L. Ludington & Sons, oyster growers.

### R20. 624–28 Quinnipiac Avenue, Justin Kimberly House, 1828–29

This early nineteenth-century vernacular-style house was built for Mr. Kimberly, a blacksmith.

### R21. 627 Quinnipiac Avenue, Obadiah Dickerman House, circa 1840

This Italian Villa–style house, on the rise overlooking the river, was built for Mr. Dickerman.

### R22. 640–42 Quinnipiac Avenue, Joseph Ames Jr. House, 1831

This Italianate-style double house was built for Mr. Ames, an oyster harvester.

**R23. 73 EAST GRAND, FIREHOUSE 17, 1927: BROWN & VON BEREN**
Replacing an earlier building down the street, this Colonial Revival–style firehouse was designed identically to the one built on Fountain Street (see O19).

**R24. 65–69 EAST GRAND AVENUE, PILGRIM CHURCH, 1851; 1906: BROWN & VON BEREN**
Formed as the Second Congregational Church of Fair Haven, the parish built this Greek Revival–style church. In 1906, the rear chapel addition was added.

**R25. 64 EAST GRAND AVENUE, OSCAR KEENY HOUSE, CIRCA 1875**
This Italianate-style house was built for Mr. Keeny, a buffer.

**R26. 61 EAST GRAND AVENUE, DANIEL FOOTE HOUSE, CIRCA 1836; CIRCA 1880**
This Italian Villa–style house was built for Mr. Foote, a confectioner down the street. The balustrade was added around 1880.

**R27. 60 EAST GRAND AVENUE, ST. JAMES EPISCOPAL CHURCH, 1844**
This Gothic Revival–style church was the first church constructed in Fair Haven Heights, and it was built of local stone on land donated by Captain Isaac Brown.

# Driving Tours

# Wooster Square Neighborhood

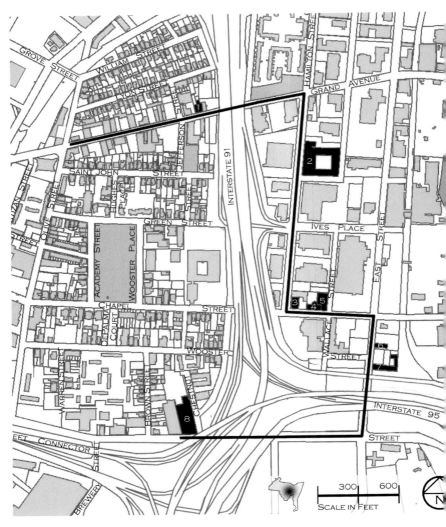

Wooster Square neighborhood driving tour map. *Compiled by Colin M. Caplan.*

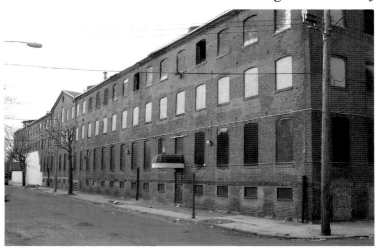

133 Hamilton Street, New Haven Clock Company, March 2007. *Photograph by Colin M. Caplan.*

### AA1. 779–83 Grand Avenue, John F. Shanley Building, circa 1895

This Romanesque Revival–style commercial building was built by Mr. Shanley, who operated a dry goods store here.

### AA2. 133 Hamilton Street, New Haven Clock Company, 1866; 1882; circa 1900; 1909; circa 1915

Sprung out of Chauncey Jerome's clock factory in 1856, this company was the largest clock manufacturer in the world. The factory had numerous additions added, as well as near bankruptcies over the years, until its closure in 1960.

### AA3. 441 Chapel Street, Durham & Booth Company, 1860–64; circa 1898

Wooster Square was the center of the city's carriage industry in the late nineteenth century. This factory building was one of more than two dozen firms operating in the area, making New Haven the carriage capital of the world.

### AA4. 438 Chapel Street, M. Armstrong & Company, 1882

This large manufacturing building was built for Montgomery Armstrong's carriage company, and it was considered one of the most efficient and modern plants when built.

### AA5. 419 Chapel Street, Yale Iron Works Building, 1870

This Italianate-style foundry building, one of the last remaining in the city, was built for William B. Pardee of the Yale Iron Works. In 1888, M. Armstrong & Company occupied the building.

### AA6. 169 East Street, W. & E.T. Fitch & Company, 1883

This Italianate machine shop was built for W. & E.T. Fitch & Company in a largely industrial area.

### AA7. 151 East Street, W. & E.T. Fitch Company, circa 1850; circa 1854; 1880–81; circa 1890 and 1906: Leoni Robinson

The W. & E.T. Fitch Company, founded in 1848 in Westville as manufacturers of carriage springs and malleable iron, purchased and built numerous buildings on this site.

### AA8. 83 Water Street, C. Cowles & Company, 1890 and 1914 and 1916: Leoni Robinson

Started in 1838 by William Cornwall and Chandler Cowles on Orange Street, this carriage parts manufacturer moved here in 1890. They were the first company in the world to install a telephone switchboard in 1878. The corner building was built in 1890, the right wing in 1914 and the left wing in 1916.

*The tour continues as a walking tour. Please refer to page 47.*

Tour BB.

# *Hill and City Point Neighborhoods*

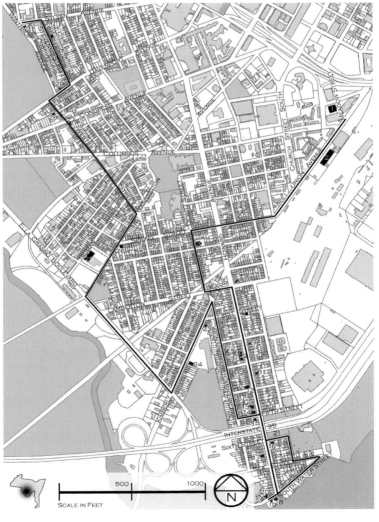

The Hill and City Point neighborhoods driving tour map. *Compiled by Colin M. Caplan.*

**BB1. 54 Meadow Street, New York, New Haven & Hartford Railroad Building, 1946–47: Douglas Orr**
New Haven's history as the center of major rail lines in the Northeast led to the construction of numerous related maintenance and office buildings. This International-style tower was one of the city's first modern office buildings.

96 Union Avenue, Union Station, March 2007. *Photograph by Colin M. Caplan.*

**BB2. 96 Union Avenue, Union Station, 1918–19: Cass Gilbert**
Constructed after the older station burned, this Beaux Arts depot, the largest between New York City and Boston, is the most important civic building in the city.

**BB3. 91 Rosette Street, Horace Day School, 1888: Leoni Robinson; 1907–08: Brown & Von Beren**
This Italianate-style school building was originally named the Rosette Street School. In 1894, its name was changed to honor Horace Day, superintendent of schools from 1856 to 1860. In 1907–08, an addition of two stories was added above the entrance.

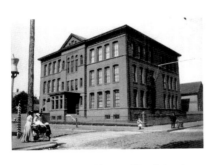

91 Rosette Street, Horace Day School, circa 1900. *Courtesy of Joseph Taylor.*

**BB4. Kimberly Square, circa 1880**
The city's smallest square is actually a triangle. Formed from the intersections of the surrounding streets, it was also known as Prohibition Square during the 1930s.

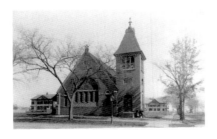

375 Howard Avenue, All St. Episcopal Church, circa 1900. *Courtesy of the New Haven Free Public Library.*

**BB5. 375 Howard Avenue, All St. Episcopal Church, 1887: Leoni Robinson**
This Queen Anne–style church was built as a parish of Trinity Episcopal Church.

**BB6. 323–25 HOWARD AVENUE, ROBERT LUTZ BUILDING, 1895**
This Italianate-style building was built for Mr. Lutz, who opened a grocery store and meat market here.

**BB7. 271 HOWARD AVENUE, ANDREW MOOREHEAD DEVELOPMENT HOUSE, 1886–89**
This Queen Anne–style house was built for Mr. Moorehead, a real estate agent who developed a number of adjacent lots.

**BB8. 260 HOWARD AVENUE, ALONZO AND WILLIAM H. LEEK HOUSE, CIRCA 1850; 1881**
This French Second Empire house was moved here in 1881 and had the third story added on by its owners, the Leeks, who were bakers.

**BB9. 254 HOWARD AVENUE, CHARLES W. HINE HOUSE, 1887**
This Queen Anne–style house was built by Mr. Hine, a wholesale liquor dealer.

**BB10. 248–50 CHARLES W. HINE HOUSE, HOWARD AVENUE, 1892**
This Queen Anne–style double house was built for Mr. Hine, who lived next door.

**BB11. 217 HOWARD AVENUE, GEORGE E. BALDWIN HOUSE, 1887**
This Queen Anne–style house was built for and by Mr. Baldwin, who worked with his sons as masons and builders.

**BB12. 198 HOWARD AVENUE, HOWARD AVENUE METHODIST CHURCH, 1875; 1889; 1890**
Originally built on Sixth Street, the church was moved here in 1889. While the church was paused in the middle of the street, the parish held a somewhat unusual Sunday service. The Gothic Revival–style front section was built by Luzerne I. Thomas, a local builder.

**BB13. 164 HOWARD AVENUE, WILLIAM M. ROWLAND HOUSE, 1885**
This Queen Anne–style house was built for Mr. Rowland, an oyster harvester at City Point.

**BB14. 154 HOWARD AVENUE, WILLIAM M. ROWLAND HOUSE, 1895**
Mr. Rowland apparently needed, and could afford, to build a new house, so he had this Queen Anne–style house built ten years after his first one.

**BB15. 142 HOWARD AVENUE, FRANK C. EBERTH HOUSE, 1897**
This Queen Anne–style house became home to Mr. Eberth, a clerk at the Security Insurance Company.

Jeremiah Smith & Sons Company, City Point, circa 1890. *Courtesy of Colin M. Caplan.*

**BB16. 95 HOWARD AVENUE, WILLIAM H. SMITH HOUSE, 1901**
This elegant Queen Anne–style house was built for Mr. Smith, secretary and treasurer of the Jeremiah Smith & Sons oyster growers.

**BB17 76–78 HOWARD AVENUE, EDWARD H. SMITH HOUSE, 1865**
This Italian Villa–style house was built for Mr. Smith, who was a partner in his family's large oyster business, Jeremiah Smith & Sons.

**BB18. 98 SOUTH WATER STREET, TRADERS DOCK, 1890; 1950**
Wharf buildings like this are extremely rare in New Haven, and were once common in this area known as Oyster Point. This Victorian-style building was used by Jeremiah Smith & Sons for their oyster business. It was shored to its present site in 1950.

**BB19. 108 SOUTH WATER STREET, OYSTER BARN, CIRCA 1890**
This small Victorian-style barn was part of a complex of structures built for the Jeremiah Smith & Sons oyster harvesters. The firm began in 1849 and became one of the largest harvesters and distributors in the world.

**BB20. 109–11 SOUTH WATER STREET, RICHARD W. LAW HOUSE, CIRCA 1849**
This Italian Villa–style house was built for Mr. Law, who started his oyster harvesting business here in 1849. Note the raised basement that allowed for the easy hauling of oysters into a workspace.

ITH & SONS, INC.
OWERS.

CITY POINT,
W HAVEN, CONN., U.S.A.

### BB21. BAY VIEW PARK, 1890

This park was established in 1890 on Camp English, the training ground of the Ninth Regiment, Connecticut Volunteers, who were dubbed the Fighting Irish. The monument built in 1903 honors those killed from the Ninth Regiment during the Civil War.

### BB22. 353 GREENWICH AVENUE, LEWIS I. FOWLER HOUSE, 1875; 2001

This Gothic Revival-style house was built for Mr. Fowler, a locomotive engineer. The house was originally located at 114 Kimberly Avenue and was moved here to make room for a school parking lot.

### BB23. 100 KIMBERLY AVENUE, PRE-1888

A superb Queen Anne-style house tastefully restored just before it was threatened with the wrecking ball.

### BB24. 168 KIMBERLY AVENUE, ST. PETER'S PARISH HALL, 1902: JOHN J. DWYER, HARTFORD

This Shingle-style church was built by St. Peter's parish and then used as a parish house when they constructed a larger stone church next door in 1930, which is now demolished.

### BB25. 114 TRUMAN STREET, TRUMAN STREET SCHOOL, 1910: BROWN & VON BEREN

One of the most dignified façades on a public school, this Neoclassical-style building, as well as the street, was named for Truman Alling, one of the largest property owners in the area.

### BB26. 670 Washington Avenue, United Illuminating Substation, 1915

As the neighborhood expanded, so did its electricity needs. The United Illuminating Company built this early transfer station.

### BB27. 798 Congress Avenue, George Bohn Building, 1890

This Romanesque Revival–style building was built by George Bohn & Sons, mason builders, who lived next door.

### BB28. 210 West Street, Phillip Fresenius House Stable, 1889: Clarence H. Stilson

This Queen Anne–style stable was built for Mr. Fresenius, owner of a brewery across the street.

### BB29. 277 Davenport Avenue, circa 1855

This transitional Greek Revival– and Italianate-style house was the only house on the block until the neighborhood was developed in the 1860s.

### BB30. 57–59 Stevens Street, Alfred Gerald Caplin House, circa 1890

This was the birthplace of Mr. Caplin, better known as Al Capp, world famous cartoonist and the creator of the popular comic *Li'l Abner*.

### BB31. 148 Sylvan Avenue, Phillips Memorials, 1877

This Italian Villa–style building was built for Thomas Phillips, whose granite and marble works studio, begun in 1845, was the oldest in the city.

Tour CC.

# Dwight Neighborhood

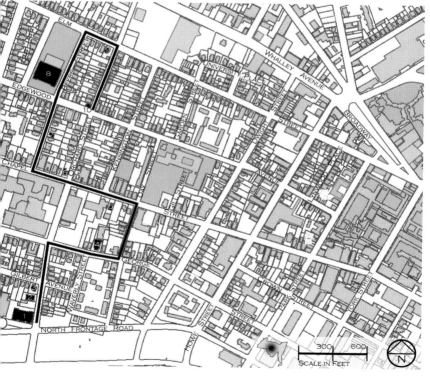

Dwight neighborhood driving tour map. *Compiled by Colin M. Caplan.*

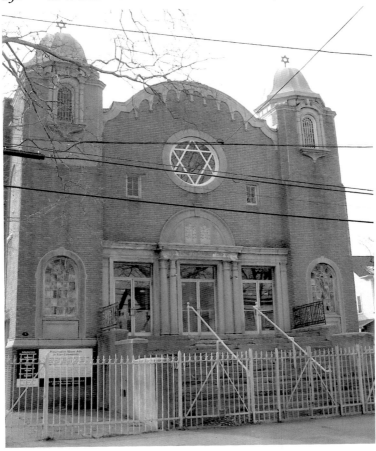

232 Orchard Street, Beth Israel Synagogue, March 2007. *Photograph by Colin M. Caplan.*

### CC1. 200 ORCHARD STREET, JESSIE I. SCRANTON SCHOOL, 1906: BROWN & VON BEREN

This Colonial Revival–style school building is named after Jessie Scranton, a teacher and supervisor at the school.

### CC2. 232 ORCHARD STREET, BETH ISRAEL SYNAGOGUE, 1924: JACOB WEINSTEIN

The Jewish community has since left the area, but this Moorish Revival–style building is the last historic synagogue in the city still being used for occasional Jewish services.

### CC3. 34 GILBERT AVENUE, HEZEKIAH GILBERT HOUSE, 1871

This Italianate-style house was built for Mr. Gilbert, who worked for the Candee Rubber Company.

**CC4. 563 George Street, St. Michael's Ukrainian Church, 1957: Julian K. Jastremsky, New York**
A terra cotta image of Jesus and robust shiny gold domes adorn this Neo-Byzantine-style church built for this Roman Catholic congregation.

**CC5. 1346 Chapel Street, George T. Bradley House, 1885: William H. Allen**
This Queen Anne-style house was built for Mr. Bradley, who was a partner in the firm Benedict & Co., coal and wood dealers.

**CC6. 1389 Chapel Street, Thomas Alling House, 1869: Rufus G. Russell; 1951; 2005: Colin M. Caplan**
This French Second Empire-style house was built for Mr. Alling, a partner with his brother George in G&T Alling, lumber supplier. A 1951 brick storefront was removed when the house was restored in 2005 and a Colonial Revival-style porch was recreated from older photographs of the house.

**CC7. 33 Beers Street, Commodore Perry Lines House, circa 1865**
Mr. Lines left a daybook behind from 1878, which not only talks about his work as a joiner and landscaper, but also tells who he talked to and where he went. He built this fascinating little Gothic house for himself.

33 Beers Street, Commodore Lines House, March 2007. *Photograph by Colin M. Caplan.*

**CC8. 259 Edgewood Avenue, Augusta Lewis Troup School, 1924–25: Charles Scranton Palmer**
This Tudor Revival-style school was named for Ms. Troup, a pioneer suffragist who lived in New Haven (see L5).

**CC9. 570 Elm Street, Frederick A. Gilbert House, 1870**
This Italianate-style house was built for Mr. Gilbert, a partner in Andrews & Gilbert, the largest painting and wallpaper contractor in the city.

**CC10. 410 Orchard Street, John Boylen House, circa 1850**
This Greek Revival-style house was built for Mr. Boylen, a painter.

*The tour continues as a walking tour. Please refer to page 63.*

# Tour DD.

# *Dixwell and Newhallville Neighborhoods*

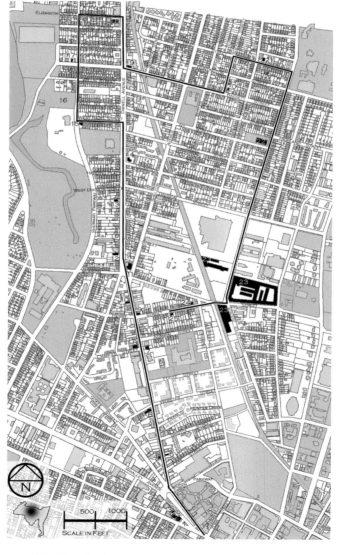

Dixwell and Newhallville neighborhoods driving tour map. *Compiled by Colin M. Caplan.*

**DD1. BROADWAY TRIANGLE, CIRCA 1820; 1905**
Elm trees were planted here around 1820, and this wide conjunction of streets became one of the city's most picturesque places. The monumental column was erected in 1905 in memory of the Civil War soldiers.

**DD2. 70 BROADWAY, CHRIST CHURCH, 1894–95 AND 1898: HENRY VAUGHN**
Begun as a parish of Trinity Church, this congregation became independent in 1856. They built this striking Gothic-style church and completed the tower in 1898.

**DD3. 80 BROADWAY, CHRIST CHURCH PARISH RECTORY, CIRCA 1805**
An elegant and intact Federal-era house, it later became the rectory for Christ Church.

**DD4. 48–50 DIXWELL AVENUE, AENEAS MUNSON HOUSE, 1830**
Mr. Munson was the son of the prominent physician Aeneas, and he built this Federal-style house, the earliest existing building in the neighborhood.

**DD5. 51–53 DIXWELL AVENUE, STEIN-ROURKE TENANT BUILDING, 1898**
This Colonial Revival–style mixed-use building was built by Isadore Stein and Frank A. Rourke, a plumber.

**DD6. 138 DIXWELL AVENUE, POLICE STATION 4, 1905–06: BROWN & VON BEREN; 1948**
This Renaissance Revival–style building replaced a house used as the police precinct. In 1942, the building was sold and converted to a community center, and in 1948 St. Martin DePorres added the rear wing and remodeled the building.

**DD7. 235 DIXWELL AVENUE, ALBERT TILTON HOUSE, 1876**
This Gothic Revival–style house was built for Mr. Tilton, a gun maker at the nearby Winchester Repeating Arms Company. In 1911, the Hannah Gray Home for poor older African American women was moved here.

**DD8. 240 DIXWELL AVENUE, VARICK MEMORIAL AFRICAN EPISCOPAL METHODIST CHURCH, 1908: BROWN & VON BEREN**
This Gothic Revival–style church was built by this congregation, which formed in 1818. In 1915, Booker T. Washington, African American educator and community leader, made his last public speech here before his death.

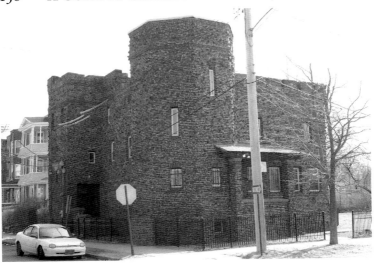

280 West Hazel Street, Schlarrafia Nova Portus, March 2007. *Photograph by Colin M. Caplan.*

### DD9. 287 Dixwell Avenue, Adolf A. Eisele Building, 1885; 1897–98

This Colonial Revival–style mixed-use building was moved closer to the street and had additions built and alterations made in 1897–98. This work was done for Mr. Eisele, a German immigrant who ran a grocery store here.

### DD10. 310 Dixwell Avenue, the Suburban Home School, circa 1851; 1895

Reverend Alonzo G. Shears was the rector of an all boys' school that was begun in 1855 and included this Italianate-style building. After the school closed, this building was moved to the street in 1895.

### DD11. 363 Dixwell Avenue, Summerfield United Methodist Church, 1891–92

Begun as the first Methodist congregation in Newhallville in 1871, the church later built this Gothic Revival–style building. In 1981, the church merged together with the First Methodist Church on Elm Street (see B5).

### DD12. 388 Dixwell Avenue, Hook and Ladder 4, 1905: Brown & Von Beren

Designed in a Neoclassical style, this former firehouse closed in 1975.

**DD13. 482 Dixwell Avenue, Gloson Hall House, 1856; circa 1925**
This Italian Villa–style house was built for Mr. Hall, who ran a meat market downtown. Around 1925, a rear addition almost doubled the size of the house.

**DD14. 555 Dixwell Avenue, Public Library, 1921: Norton & Townsend**
This Neoclassical-style building was built as the neighborhood branch library.

**DD15. 280 West Hazel Street, Schlarrafia Nova Portus, 1930: Martin Bariffi**
The immigrant German community built this clubhouse for the Schlarrafia Nova Portus German educational and social club, founded in 1905. It was designed like a medieval fortress with parapets, tiny windows and a tower.

**DD16. Beaver Pond Park**
The ponds, which are deep glacial sinkholes flooded by beaver dams and then by colonial-era mill dams, were later known for shady activities near Hell's Alley, a shantytown of Polish immigrants located north of Bassett Street in the early 1900s.

**DD17. 317 Bassett Street, Robert Gowie House, 1875**
This Italianate-style house was built for Mr. Gowie, who was employed by Arthur N. Farnham, a horticulturist on Crescent Street.

**DD18. 786 Dixwell Avenue, St. John the Baptist Church, 1921–22: Joseph A. Jackson, New York**
This Gothic Revival–style church was built for this Roman Catholic parish, which was founded around 1890.

**DD19. 705 Dixwell Avenue, Gabriel Derosa Tenement House, 1909: Bailey & D'Avino**
This handsome Colonial Revival–style three-family flat was built as a speculative real estate venture for Mr. Derosa, a farmer in Westville.

**DD20. 7 Shepard Street, Henry Kingsley House, pre-1879**
This tiny French Second Empire–style cottage was built as a speculative real estate venture for Mr. Kingsley, treasurer of Yale University.

**DD21. 45 Read Street, John Moore Jr. House, 1869**
This Italian Villa–style house was built for Mr. Moore, a carriage trimmer at George T. Newhall Carriage Emporium.

**DD22. 15 Ivy Street, Ivy Street School, 1907: Brown & Von Beren**

As the neighborhood's population boomed, the need for larger school quarters grew. The city built this robust Classical Revival-style building, which is no longer used as a school.

**DD23. 275 Winchester Avenue, Winchester Repeating Arms Company, 1870; 1883; 1892–1916 and 1932: Leoni Robinson**

Founded by Oliver Winchester in 1866, the sprawling plant covered eighty-one acres and was the largest employer in the city at its peak during the World Wars. The factory was built near the site of the George T. Newhall Carriage Emporium in the neighborhood called Newhallville.

**DD24. 27–29 Henry Street, Joseph Sheldon Tenant House, 1884; 1915: Shiner & Appel**

Originally built as a small Victorian Gothic-style house by Mr. Sheldon, it was altered and enlarged for Damon Holmes's restaurant.

**DD25. 58–62 Henry Street, Joseph Sheldon Tenant Houses, 1878**

This was another investment property built by Mr. Sheldon, a city court judge and lawyer. This short row is designed in Italianate style.

# State Street, East Rock and Cedar Hill Neighborhoods

State Street and East Rock neighborhoods driving tour map. *Compiled by Colin M. Caplan.*

**EE1. 380 ORANGE STREET, TEMPLE MISHKAN ISRAEL, 1896–97: BRUNNER & TRYON, NEW YORK**
This Byzantine Revival–style synagogue is the oldest existing building in the city built for the Jewish community. The congregation was the first in the state, organized by German immigrants in 1840.

**EE2. 385 ORANGE STREET, EDWARD RUSSELL HOUSE, 1886**
This Queen Anne–style house was built for Mr. Russell, who operated Russell Brothers, New York, Butter House, on State Street.

**EE3. 389 ORANGE STREET, EBEN THOMPSON HOUSE, 1856**
This Italian Villa–style house was built for Mr. Thompson, a grocer on State Street.

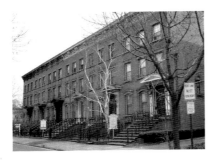

405–15 Orange Street, Smith & Sperry row houses, March 2007. *Photograph by Colin M. Caplan.*

**EE4. 405–15 ORANGE STREET, SMITH & SPERRY ROW HOUSES, CIRCA 1864**
Italianate-style rows like this one were commonly built in the area, many of them constructed by the prominent firm of Smith & Sperry.

**EE5. 412 ORANGE STREET, SAMUEL E. MERWIN JR. HOUSE, 1857**
This Italian Villa–style house was built for Mr. Merwin, who ran a grocery store on State Street. He was adjutant general during the Civil War and was called to arrest a gang of one hundred ruffians from New York who prepared to hold a prize fight on Charles Island, off Milford coast.

**EE6. 37–39 TRUMBULL STREET, LOUIS BERMAN BUILDING, 1919–20: BROWN & VON BEREN**
This Renaissance Revival–style apartment building is representative of a number of large residential buildings constructed in this area during the 1920s.

**EE7. 431 ORANGE STREET, TIMOTHY LESTER HOUSE, 1846**
This dignified Italian Villa–style house, one of the first of this type in the city, was built for Mr. Lester, who worked at L.C. Candee & Co., boot manufacturer.

**EE8. 445 ORANGE STREET, WILLIAM DEFOREST HOUSE, 1858–59**
This Italian Villa–style house, originally covered with stucco, was built for Mr. DeForest, a physician.

**EE9. 442 ORANGE STREET, JOHN C. ANDERSON HOUSE, 1882: JOHN KEELY, NEW YORK**
One of the city's best examples of French Second Empire style, this mansion was built for Mr. Anderson, who inherited a fortune from his father's tobacco interests. The building eventually became part of St. Mary Academy High School.

**EE10. 466 ORANGE STREET, NEHEMIAH SPERRY HOUSE, 1857**
This Italianate-style house was built for and by Mr. Sperry, who along with his bother Willis was a prominent builder under the firm Smith & Sperry.

**EE11. 478 ORANGE STREET, FREDERICK IVES HOUSE, 1866**
This Italian Villa–style house was built for Mr. Ives, partner of Ives & Miller, axle manufacturer.

**EE12. 484 ORANGE STREET, WATSON COE HOUSE, 1867–68**
The number of Italian Villa–style houses like this one proves this style's popularity during this period.

**EE13. 495 ORANGE STREET, ENOS S. KIMBERLY HOUSE, 1884: RUFUS G. RUSSELL**
This Queen Anne–style house was built for Mr. Kimberly on the site of an earlier house, which was likely moved away somewhere.

**EE14. 548 ORANGE STREET, THE BELNORD APARTMENT BUILDING, 1915: JACOB WEINSTEIN**
This large apartment building was designed with Mission-style elements.

**EE15. 545–51 ORANGE STREET, NELSON NEWGEON HOUSES, 1869–69**
Mr. Newgeon, a builder, constructed this row of lavish French Second Empire–style houses.

**EE16. 574 ORANGE STREET, ST. JOHN EPISCOPAL CHURCH, 1895: W. HALSEY WOOD, NEW YORK**
The English countryside seems to have arrived on Orange Street when you look at this Gothic-style church.

**EE17. 291 HUMPHREY STREET, HUMPHREY STREET SCHOOL, 1877: RUFUS G. RUSSELL**
This Victorian Gothic–style school building is one of the city's oldest existing schools; it is now the Polish National Home.

**EE18. 280 HUMPHREY STREET, GERMAN EMANUEL LUTHERAN CHURCH, 1927: BROWN & VON BEREN**
German immigrants settled in this area built this miniature Gothic Revival church.

### EE19. 922–28 State Street, Atwater-Zernitz Building, 1885

The carved brownstone is noteworthy on this Italianate-style mixed-use building. It was built William J. Atwater, a real estate speculator, and sold to Edmund Zernitz, a watch and jewelry dealer, in 1887.

### EE20. 20 Bishop Street, Ellen Sheehan House, 1892

This is an excellent example of a highly articulated Queen Anne flat, built for Ms. Sheehan.

### EE21. 23 Bishop Street, Franc Merwin Smith House, 1898

This Italianate-style three-family flat was built by Mr. Smith and then sold to Fredrique Lewis, a real estate agent.

### EE22. 625 Orange Street, Knickerbocker Apartments, 1919: Jacob Weinstein

When it was built, this large Renaissance Revival-style apartment building must have shocked the smaller-scaled neighborhood.

### EE23. 655 Orange Street, Epworth Methodist Episcopal Church, 1892

Long before being absorbed into the First Methodist Church on Elm Street, this congregation built this Romanesque Revival-style church.

### EE24. 726 and 730–32 Orange Street, George and John Matthews Houses, 1883

Both houses are matching pairs designed in the Stick style for two brothers.

### EE25. 763–65 Orange Street, Hall Benedict Drug Company, 1909: Frank Elmwood Brown

Alonzo B. Hall built this Victorian-style drugstore, started in 1870, which became the Hall Benedict Drug Company after partnering with Edward N. Benedict.

### EE26. 125 Linden Street, Frederick C.H. Carder House, 1908

This Shingle-style house was built by John H. Thompson for Mr. Carder, a clerk at the Winchester Repeating Arms Company.

### EE27. 180 Canner Street, Worthington Hooker School, 1899–1900: Brown & Von Beren

Named for Mr. Hooker, a prominent local physician, the city built this Beaux Arts-style school as the neighborhood's population boomed.

### EE28. 244 Livingston Street, Noble P. Bishop House, 1909: Brown & Von Beren

This curvy Shingle-style house was built for Mr. Bishop, president and treasurer of the Foskett and Bishop Co., heating and plumbing company.

### EE29. College Woods, 1877
Dating back to the eighteenth century, this area was used by Yale College for firewood harvesting. Many of the large oaks were planted during that period. In 1877, the land was donated to the city and is now part of East Rock Park.

### EE30. 370 Livingston Street, Dr. Herman P. Hessler House, 1929: J. Frederick Kelly
This Colonial Revival–style house was built for Dr. Hessler, a physician.

### EE31. East Rock Park, 1877–84

East Rock from the Orange Street bridge over the Mill River, circa 1895. *Courtesy of Colin M. Caplan.*

One of the city's most beautiful and most visible parks, East Rock Park was formed by the acquisition of donated land in 1877 and the eminent domain purchase from the mountain-dwelling hermit named Steward in 1884. The tour now goes through the somewhat isolated Cedar Hill neighborhood.

### EE32. 83–85 Willow Street, Marlin Firearms Company, 1870; circa 1880; 1930

83–85 Willow Street, Marlin Firearms Company, March 2007. *Photograph by Colin M. Caplan.*

John H. Marlin started selling his own revolvers in 1870 and started one of the most successful firearms companies in the city. The company was one of the largest producers of machine guns in the world during World War I.

### EE33. 45 Nash Street, Lovell School, 1889–90: Leoni Robinson; 1910: Brown & Von Beren
This building was named for John E. Lovell, headmaster of the Lancasterian School, which became the James Hillhouse Public School in 1856. The front section was added to this Italianate-style school in 1910.

### EE34. 15–19 Edwards Street, Firehouse 8, 1874; 1942
Like many of the Victorian style firehouses, this building was remodeled in 1942, and in 1974 it was converted to offices.

### EE35. 978–80 State Street, 1887
State Street's commercial prominence in the area was augmented by the construction of mixed-use blocks like this Italianate-style building.

### EE36. 1013–17 State Street, Joseph Glitch Building, 1889
This Romanesque-style building was built for Mr. Glitch, an agent for breweries.

### EE37. 175 Humphrey Street, 1860–76
Marking the corner, this Italianate-style mixed-use building was built to reflect the local wealth in an area that previously would not have imagined such a building

### EE38. Franklin Square, 1835: Nathaniel and Simeon Jocelyn
The park is now named Jocelyn Square after its designers, the Jocelyn brothers, artists, social reformers and real estate speculators who also created Spireworth Square (see E2).

### EE39. 855 State Street, Swedish Evangelist Lutheran Church, 1904–05: Brown & Von Beren
This Gothic Revival-style church was built for this Swedish parish.

### EE40. 790 State Street, St. Stanislaus Roman Catholic Church, 1912–13: Chickering & O'Connell, Boston
Polish immigrants founded this church in the late 1890s and named it in 1901. They were able to build their first church here, designed in Romanesque Revival style. The school next door was built in 1923.

### EE41. 780 State Street, John B. Wright Building, 1890–91
This Italianate-style mixed-use building housed Mr. Wright's family member, O. Scott Wright, and his appliance store and plumbing company in 1891.

### EE42. 630 State Street, St. Boniface Roman Catholic Church, 1923: George Zunner, Hartford
The German Catholic community built this Gothic Revival-style church building, their second building since the parish's founding in 1858.

Tour FF.

# Prospect Hill and Whitney Avenue

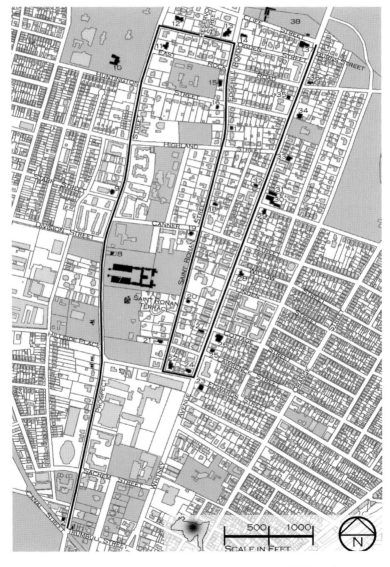

Prospect Hill and Whitney Avenue driving tour map. *Compiled by Colin M. Caplan.*

**FF1. 91 Trumbull Street, Wolf's Head, 1884: McKim, Mead & White, New York**

This Yale senior society building was designed by an architectural firm mentored by H.H. Richardson. Likewise, this brownstone building was designed in the Richardson Romanesque style.

**FF2. 88 Prospect Street, circa 1830; circa 1865**

This Federal-style house was likely moved here around 1865.

**FF3. 310 Prospect Street, John Schwab House, 1896: R. Clipston Sturgis, Boston**

This Tudor Revival–style mansion was built for Mr. Schwab, professor of political economy at Yale.

**FF4. 314 Prospect Street, Alexander Catlin Twining House, 1880: Brown & Stilson**

This Queen Anne– and Stick-style mansion was built for Mr. Twining, an engineer who invented the first widely used ice machine in the country in 1849.

**FF5. 360 Prospect Street, Othniel Marsh House, 1878: J.C. Cady & Co., New York**

This house was built for Mr. Marsh, who was considered to be the father of American paleontology. He often organized trips to the Western territories and provided support to Charles Darwin's theories of evolution. In 1899, this Queen Anne–style house was given to Yale for the Forestry School.

**FF6. 393 Prospect Street, John M. Davies House, 1868: Henry Austin and David R. Brown**

This house was the largest of its time and was the most important French Second Empire in the city. Mr. Davies co-owned a shirt manufacturing company with Oliver Winchester.

**FF7. 409–23 Prospect Street, Yale Divinity School, 1931: Delano & Aldrich, New York**

As Yale's campus expanded, there were greater opportunities for large developments. The plan of the Divinity School was based on Thomas Jefferson's University of Virginia Federal-era design.

**FF8. 459 Prospect Street, Yale University Observatory Officers' House, 1882**

This colorful Queen Anne–style house was built for officers of Yale's observatory, which is located in the block behind. The first officer to live here was Leonard Waldo.

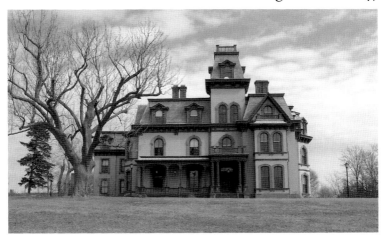

393 Prospect Street, John M. Davies House, March 2007. *Photograph by Colin M. Caplan.*

### FF9. 500 PROSPECT STREET, SAMUEL YORK HOUSE, 1905: BROWN & VON BEREN

Hollow concrete blocks were used to construct this Beaux Arts mansion. It was built for Mr. York, a lawyer and city clerk of New Haven.

### FF10. 700 PROSPECT STREET, LOUIS STODDARD HOUSE, 1905: PEABODY & STEARNS, BOSTON

The largest house in New Haven, it was designed in the Colonial Revival style following James Hoban's design of the White House in Washington, D.C. It was built as a wedding present by his father-in-law, Mr. Stoddard, president of the Factory Products Export Co. and the New Haven Hotel Co. In 1925, it became Rosary Hall, the first Catholic liberal arts, residential college for women in New England.

### FF11. 755 PROSPECT STREET, DR. BENJAMIN AUSTIN CHENEY HOUSE, 1918: ROSSITER & MULLER, NEW YORK

This Tudor Revival–style mansion was built for Dr. Cheney, a gynecologist and one of the founders of Grace Hospital.

### FF12. 787 PROSPECT STREET, HIRAM BINGHAM HOUSE, 1909: CHAPMAN & FRAZER, BOSTON

This Spanish Villa–style mansion was built for Professor Bingham, a prominent archaeologist who discovered the ruins of Machu Picchu in Peru and was governor of Connecticut in 1924. In 1939, the house became the New Haven Women's College and then part of Albertus Magnus College in 1946.

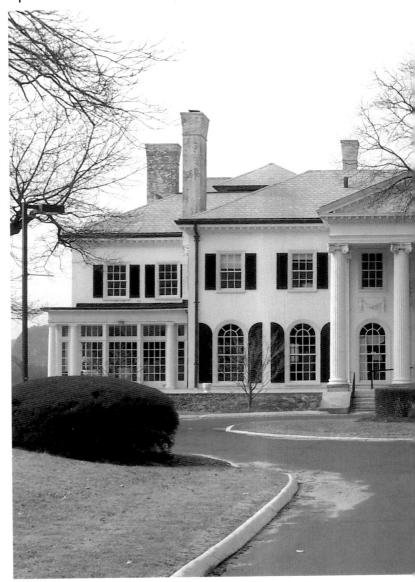

700 Prospect Street, Louis Stoddard House, March 2007. *Photograph by Colin M. Caplan.*

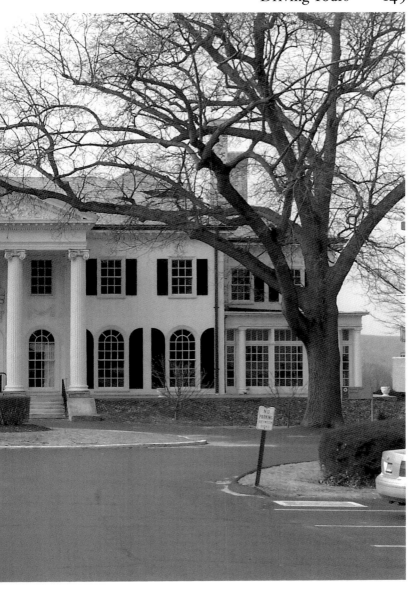

### FF13. 123 Edgehill Road, Elizabeth Hooker House, 1914: Delano & Aldrich, New York

This Tudor Revival–style house was built for Ms. Hooker, daughter of Frank Henry Hooker, president of the Henry Hooker & Company, carriage manufacturers.

### FF14. 100 Edgehill Road, Hayes Quincy Trowbridge House, 1907–08: Peabody & Stearns, Boston

This Shingle-style house was built for Mr. Trowbridge, who operated a trust and estate management company.

### FF15. 50 Edgehill Road, Aaron Alling House, 1905: Brown & Von Beren

This eclectic Tudor- and Dutch Colonial Revival–style house was built for Mr. Alling, a partner in the law firm Alling, Web & Morehouse.

### FF16. 24 Edgehill Road, Oliver C. Andrews House, 1899: Leoni W. Robinson

Although this Colonial Revival–style house was built for Mr. Andrews, in 1906 it became home to Wilbur Cross, professor and dean of the Graduate School at Yale as well as a four-term governor of Connecticut from 1931 to 1939.

### FF17. 7–9 Edgehill Road, Eli Whitney Jr. House, circa 1859; circa 1897

One of the most characteristic Gothic Revival–style houses in the city, it was built as a cottage for Mr. Whitney. The house was rotated to face the street when the road was laid on the property around 1897.

### FF18. 389 Saint Ronan Street, Reverend John C. Collins House, 1889

This Shingle-style house was built for Reverend Collins, pastor of the Christian Workers of USA and Canada, but it was later home to Ms. Augusta "Gussie" Troup, a pioneer women's suffragist and founder of the Women's Typographical Union No. 1. She also assisted and educated poor immigrants in New Haven.

### FF19. 346 Saint Ronan Street, William A. Warner House, 1909: Brown & Von Beren

This Colonial Revival–style house was built for Mr. Warner, partner of the Warner-Miller Co., mason suppliers.

### FF20. 257 Saint Ronan Street, Reverend John C. Collins House, 1886

This Queen Anne–style house was built for Rev. Collins, who soon after moved up the street.

**FF21. 208 Saint Ronan Street, Esther Porter House, 1884–85**
This Queen Anne-style house was built for Ms. Porter, widow of Horace Porter. In 1914, Paul Benedict lived here and experimented with using the house's tower for radio transmissions.

**FF22. 309 Edwards Street, Henry Bradley House, 1905: Allen & Williams**
This Georgian Colonial Revival-style house was built for Mr. Bradley, head of Edward M. Bradley & Co., bankers and brokers, one of the first companies in the country to finance utility companies.

**FF23. 321 Whitney Avenue, Atwater-Ciampolini House, 1890: Babb, Cook & Willard, New York**
The best example of Shingle-style in city, this house was built for Charles E. and Helen G. Atwater.

**FF24. 332–34 Whitney Avenue, Williston Walker House, 1901: Edward T. Hapgood, Hartford**
This Colonial Revival-style house was built for Professor Walker, a professor of ecclesiastical history at Yale. The house was also home to both U.S. Presidents George H.W. and George W. Bush.

**FF25. 357 Whitney Avenue, Lemuel G. Hoadley House, 1897: William Allen**
This Queen Anne-style mansion was built for Mr. Hoadley, a real estate broker.

**FF26. 389 Whitney Avenue, Charles S. Mellon House, 1893**
This Queen Anne-style mansion was built for Mr. Mellon, president of the New York, New Haven & Hartford Railroad.

**FF27. 388 Whitney Avenue, George B. Stevens House, circa 1888**
This Queen Anne-style house was built for Mr. Stevens, a professor at Yale.

**FF28. 475 Whitney Avenue, Colin M. Ingersoll House, 1896: Joseph W. Northrop, Bridgeport**
Perhaps the city's most striking residence, this Chateauesque-style mansion was built for Mr. Ingersoll, the chief engineer of the New York, New Haven & Hartford Railroad.

**FF29. 569 Whitney Avenue, Charles T. Coyle House, 1908–09**
This Colonial Revival-style house was built for Mr. Coyle, who began developing real estate in this area and the Hill neighborhood.

641 Whitney Avenue, Richard Everit House, circa 1870. *Courtesy of Joseph Taylor.*

### FF30. 575 WHITNEY, CHURCH OF THE REDEEMER, 1949–50: DOUGLASS ORR
This late example of Colonial Revival style is worth taking note of for its simple elegance.

### FF31. 591 WHITNEY AVENUE, CLARA I. MOELLER HOUSE, CIRCA 1909
This unusually elegant double-bay Colonial Revival–style house was built for Ms. Moeller.

### FF32. 592 WHITNEY AVENUE, RICHARD WILLIAMS HOUSE, 1902: RICHARD WILLIAMS
This Shingle-style house was built for Mr. Williams, a successful architect who designed the Elm Street Courthouse, among other notable buildings.

### FF33. 641 WHITNEY AVENUE, RICHARD EVERIT HOUSE, 1866–67
This striking Victorian Gothic mansion, one of the large estates built along Whitney Avenue dating from the mid-nineteenth century, was built for Mr. Everit, who was a shipping merchant.

**FF34. 703 WHITNEY AVENUE, ABNER HENDEE HOUSE, 1900: RICHARD WILLIAMS**
This elegant Shingle-style mansion was built for Mr. Hendee, owner of a flour, grain and hay business.

**FF35. 724 WHITNEY AVENUE, EDWARD S. PERRY HOUSE, 1900: WILLIAM H. ALLEN**
This Colonial Revival–style house was built for Mr. Perry, a commercial travel agent.

**FF36. 749 WHITNEY AVENUE, GEORGE MASON HOUSE, 1848**
This Italian Villa–style house was built for Mr. Mason, a gunsmith at the Whitney Armory up the street in Hamden.

**FF37. 794–830 WHITNEY AVENUE, ST. THOMAS EPISCOPAL CHURCH, 1938: ALLEN, COLLENS & WILLIS, BOSTON**
This Neo Gothic–style church was built for this congregation, which moved here from its original Elm Street location (see A21). The parish house, which was constructed in 1930, predated this building.

**FF38. EDGERTON PARK**
Only the massive stone walls, gatehouse, greenhouses and stables exist from the 1910 estate of Frederick Brewster. This was New Haven's largest and most lavish house, but Mr. Brewster willed that the house be demolished and the estate was donated to the city in 1963.

# *Beaver Hills and Westville Neighborhoods*

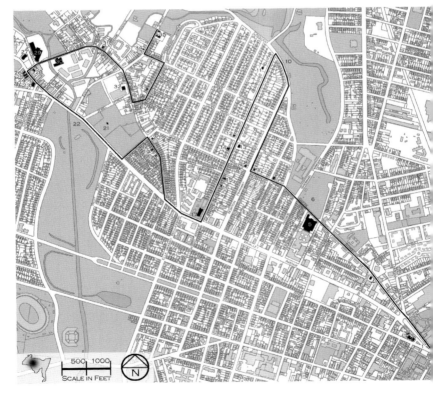

Beaver Hills and Westville neighborhoods driving tour map. *Compiled by Colin M. Caplan.*

**GG1. Broadway Triangle, circa 1820; 1905**
Elm trees were planted here around 1820, and this wide conjunction of streets became one of the city's most picturesque places. The monumental column was erected in 1905 in memory of the soldiers of the Civil War.

**GG2. 70 Broadway, Christ Church, 1894–95 and 1898: Henry Vaughn**
Begun as a parish of Trinity Church, this congregation became independent in 1856. They built this striking Gothic-style church and completed the tower in 1898.

**GG3. 80 Broadway, Christ Church Parish Rectory, circa 1805**
An elegant and intact Federal-era house, this later became the rectory for Christ Church.

**GG4. 106 Goffe Street, Goffe Street Special School, 1864: Henry Austin**
The design for this Italianate-style schoolhouse was donated by the architect. In 1874, the school closed after the school system was desegregated, and in 1929 it became a Masonic hall.

**GG5. 270 Goffe Street, State Armory, 1929**
This giant Romanesque Revival–style building replaced the armory formerly located on Meadow Street. Situated behind the old county jail, the armory served numerous purposes, including a drill house, auditorium and exposition center.

**GG6. DeGale Field**
The fields here, which were originally swampy springs, were filled in the 1890s and converted into baseball fields. The Elm City Colored Giants, managed by Walter "Pop" Smith, played here. The park was also home to football games and the circus.

**GG7. 591 Winthrop Avenue, Beaver Hills Tennis Clubhouse, 1913; Foote & Townsend**
The Beaver Hills Company was the first developed neighborhood in the city that offered activities like tennis, for which this Bungalow-style clubhouse was built. In 1926, there were more than two hundred members from across the city.

**GG8. 389 Norton Parkway, Charles M. Dobbs House, 1910: Foote & Townsend**
This Bungalow-style house was built for Mr. Dobbs, the secretary and treasurer of the Monarch Laundry Company.

### GG9. 390 Norton Parkway, Beaver Hills Company House, 1908; Foote & Townsend

This Bungalow-style house was the first house built on the development tract, even prior to the construction of the street through this block. The Mead family organized the Beaver Hills Company and it was one of the first planned residential neighborhoods in the country built for automobile access.

### GG10. Beaver Pond Park

The ponds, which were deep glacial sinkholes flooded by beaver dams and then by colonial-era mill dams, were later known for shady activities near Hell's Alley, a shantytown of Polish immigrants located north of Bassett Street in the early 1900s.

### GG11. 636 Ellsworth Avenue, A. Allen Johnson House, 1938: Lewis Bowman, New York

This Tudor Revival–style house was built for Mr. Allen, head of the Johnson's Wholesale Perfume Company.

### GG12. 488 Ellsworth Avenue, Alexander C. Middleton House, 1913: Charles F. Townsend

This Tudor Revival–style house was built by the Beaver Hills Company for Mr. Middleton, a foreman at the General Electric Company.

### GG13. 475 Ellsworth Avenue, Alfred H. Powell House, 1921: Roy W. Foote

This Spanish Colonial Mission–style house, the most dignified in the city, was built for Mr. Powell, president and treasurer of the A.H. Powell & Co., wholesale coal dealers.

### GG14. 460 Ellsworth Avenue, Frank E. Edgar House, 1912

This rustic Bungalow-style house was built by the Beaver Hills Company for Mr. Edgar, a commercial travel agent.

### GG15. 409 Ellsworth Avenue, Vito Zichichi Development House, 1920

This intricately ornamented Colonial Revival–style multi-family flat was built by Mr. Zichichi, a builder and real estate developer.

### GG16. 391 Ellsworth Avenue, Hartog-Walker House, 1889–90

This small Queen Anne–style house was built as a speculative real estate venture for Ferdinand Hartog and later sold to George K. Walker, a clerk at the Winchester Repeating Arms Company.

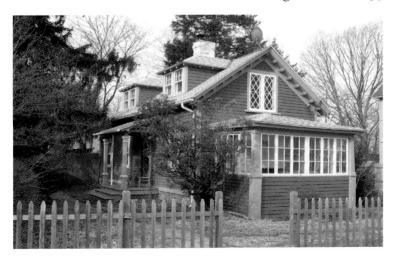

96 Blake Street, Deacon John White Jr./Thomas Bills House, March 2007.
*Photograph by Colin M. Caplan.*

### GG17. 435 WHALLEY AVENUE, ST. BRENDAN'S ROMAN CATHOLIC CHURCH, 1922: WHITON & MCMAHON, HARTFORD

This congregation built this Gothic Revival-style church on land that was part of the Oak Hill estate.

### GG18. 96 BLAKE STREET, DEACON JOHN WHITE JR./THOMAS BILLS HOUSE, CIRCA 1750; CIRCA 1795; CIRCA 1805; CIRCA 1850; 1922

Captain John White sold this Colonial house to his son, Deacon John Jr., in 1752, and in 1760 it became home to Thomas Bills, a highly respected civic leader and one of the master masons involved in constructing Yale's oldest existing building, Connecticut Hall. The house has been added to and remodeled a number of times over the years.

### GG19. 114 BLAKE STREET, MARCUS SHUMWAY HOUSE, CIRCA 1870

This pristine French Second Empire house was built for Mr. Shumway, a molder and superintendent of the Blake Brothers Manufacturing Co., once located a few blocks down the street. Mr. Shumway was also one of the founders of the Westville Methodist Church. In 1911, the house was moved to the front of the lot.

### GG20. 129 BLAKE STREET, PETER MAVERICK/LEAVERETT BRADLEY HOUSE, CIRCA 1797

This Federal-style house was built for Peter Maverick and in the 1830s–40s it was remodeled with Greek Revival-style elements by Mr. Bradley. Marcus Shumway and his family lived in this house starting in 1836.

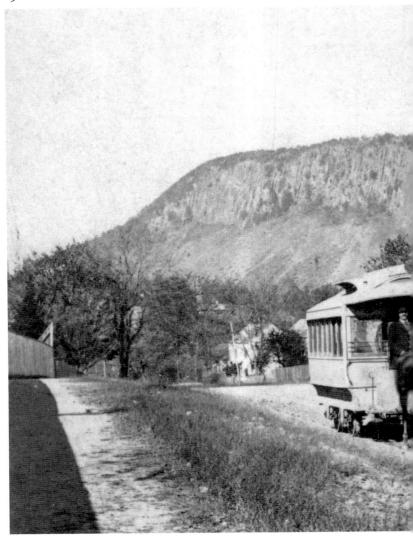

West Rock from Whalley Avenue at the cemetery, circa 1868. *Photograph by Henry S. Peck. Courtesy of Colin M. Caplan.*

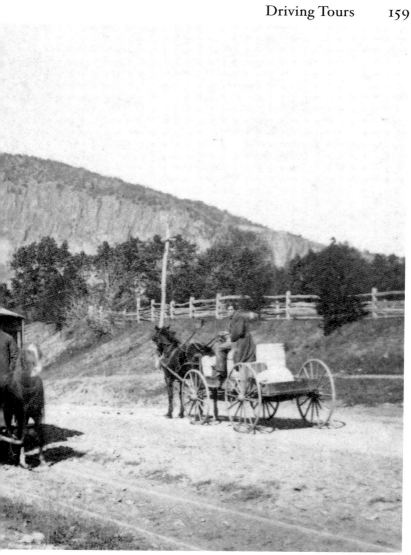

## GG21. WHALLEY AVENUE, WESTVILLE AND MISHKAN ISRAEL CEMETERIES, 1833; 1843; 1910: BROWN & VON BEREN

The Westville School District started this burial ground in 1833. The Jewish congregation Mishkan Israel followed suit and purchased adjacent land in 1843. In 1910, Mishkan Israel erected an Assyrian-style mortuary chapel.

## GG22. EDGEWOOD PARK, 1889: DONALD GRANT MITCHELL AND FREDERICK LAW OLMSTED JR.

The park was created by Mr. Mitchell, a prolific author during the mid- to late nineteenth century, and Mr. Olmsted, designer of New York City's Central Park. The park's name is derived from Mr. Mitchell's adjacent farm, which he named Edgewood. The West River that runs through the center of the park was straightened, creating curious, murky oxbow ponds.

## GG23. 882–88 WHALLEY AVENUE, HOTEL EDGEWOOD, CIRCA 1830; CIRCA 1890; 1913: CHARLES E. JOY

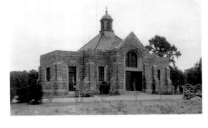

This Colonial Revival–style building is actually two buildings, a part of which was built here as a house around 1830. Attached to the left-hand side of the house around 1890 was a building called Franklin Hall, which was previously a middle school moved from Harrison Street to Fountain Street around 1878. In 1913, the buildings were unified with one roof and additions were added.

Whalley Avenue, Mishkan Israel Cemetery Chapel, circa 1910. *Courtesy of the New Haven Museum and Historical Society.*

## GG24. 904–06 WHALLEY AVENUE, KNIGHTS OF PYTHIAS HALL, CIRCA 1887

This Queen Anne–style building was built for Harriet Sperry, who lived next door. The Knights of Pythias used the building for their assembly hall.

## GG25. 908–12 WHALLEY AVENUE, JAMES THOMPSON JR. HOUSE, CIRCA 1750

This Colonial-era house, probably the oldest in Westville, passed through many owners, including Alfred C. and Harriet Sperry in 1847. The Sperrys lived here and ran a store in the front.

### GG26. 914–18 WHALLEY AVENUE, HOTCHKISS-ALLING HOUSE, CIRCA 1795

This Federal-era house was built by the Hotchkiss family, whose relative Sheriff Joshua Hotchkiss was the area's first known resident in 1658. In 1822, Lyman Alling purchased the house and his relative, Claudius Alling, ran a butcher shop here.

### GG27. 949 WHALLEY AVENUE, MASONIC TEMPLE, 1926: ROY W. FOOTE

This Colonial Revival–style building was used as an assembly hall for the local Masonic lodge.

### GG28. 512 BLAKE STREET, JAMES G. HOTCHKISS HOUSE, CIRCA 1840; 1926

This Greek Revival–style house was built for Mr. Hotchkiss, a match maker at the Diamond Match Company down the street. Originally built at the corner, the house was moved here when the Masonic temple was built in 1926.

### GG29. 495 BLAKE STREET, GEOMETRIC TOOL COMPANY BUILDING, 1906: BROWN & VON BEREN; 1912; 1915

Built on the site of mills dating from the Colonial period, the Geometric Tool Company built tool and drill parts.

### GG30. 446 BLAKE STREET, GREIST MANUFACTURING COMPANY BUILDING, 1906: BROWN & VON BEREN; 1910: PHILIP SELLERS

John Milton Greist started selling sewing machines with his mother and founded this company in 1871. The company moved into a plant here in 1892 and became the world's largest producer of sewing machine attachments.

### GG31. 355 BLAKE STREET, JOHN BLAKE HOUSE, 1841

This Greek Revival–style house was built for Mr. Blake, head of Blake Brothers Manufacturing Co., hardware manufacturers and the first company in the world to make mortised door locks and latches.

### GG32. 250 BLAKE STREET, LUCIUS WHEELER BEECHER SCHOOL, 1913: BROWN & VON BEREN

Built by the Westville School District, this school building with Tudor Revival–style elements was named for Mr. Beecher, manager of the Diamond Match Company at Blake and Valley Streets.

### GG33. 44 DIAMOND STREET, HENRY HOUSER HOUSE, 1875–76

This striking Gothic Revival–style house was built by Mr. Houser for the workers of his company, the West Rock Wagon Works, across the street.

## GG34. 202 FITCH STREET, MARCUS SHUMWAY HOUSE, CIRCA 1820; 1868–76

This Gothic Revival–style house was possibly built across the street for Jason Potter. Between 1868 and 1876, the house was moved here and remodeled by Marcus Shumway, a local developer and superintendent at Blake Brothers.

## GG35. 239 AND 249 FITCH STREET, NORMAN DEXTER HOUSES, 1823–25

These once matching Federal-style houses were built to house laborers at Mr. Dexter's comb factory, adjacently located along Beaver Brook.

# *Fair Haven Neighborhood*

Fair Haven neighborhood driving tour map. *Compiled by Colin M. Caplan.*

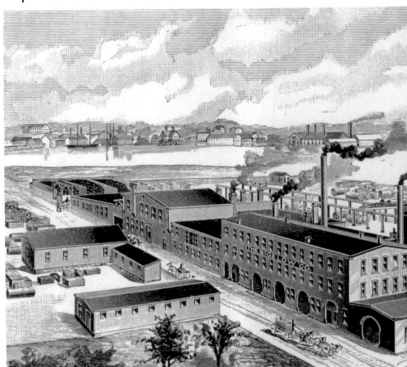

198–200 River Street, Bigelow Boiler Company, circa 1895. *Courtesy of Colin M. Caplan.*

### HH1. CRISCUOLO PARK, 1890

The Park Commission acquired this open space in 1890; it was originally named Grapevine Point. In 1862, it was used as a conscript camp called Camp Terry during the Civil War. Many of the conscripts, making up five regiments from all over New England, were bounty jumpers trying to escape imprisonment.

### HH2. 277 CHAPEL STREET, HENRY G. THOMPSON & SON COMPANY, 1917: LOCKWOOD, GREEN & CO., SOUTH CAROLINA

This 55,000-square-foot industrial building was built by Henry G. Thompson & Son Company, which began in Milford in 1876. In 1937, the company was the world's largest manufacturer of flexible-back metal saw blades.

### HH3. 264 CHAPEL STREET, SAMUEL L. BLATCHLEY TENEMENT HOUSE, CIRCA 1884

This is the lone survivor of an Italianate-style brick row built by Mr. Blatchley, a prominent local developer.

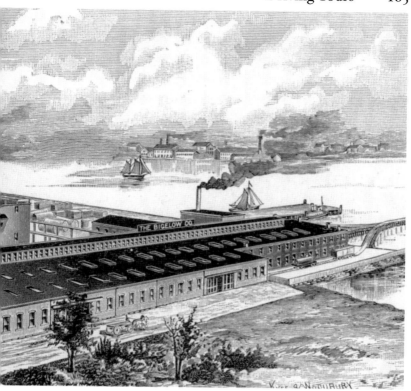

**HH4. 198–200 River Street, Bigelow Boiler Company, 1881; 1884; 1886; 1906; 1918–21**
Hobart B. Bigelow started this boiler manufacturing business in 1861 and later manufactured the largest piece of equipment to ever come out of the city. Numerous additions, replacements and alterations have occurred since the company moved to the site in 1869.

**HH5. 142 River Street, National Pipe Bending Company, 1890–93; 1900; 1906; 1910–11: Phillip Sellers**
Founded in 1882 by Hobart B. Bigelow and others, the National Pipe Bending Company made coils for the boilers at Bigelow's plant. Originally located across River Street, the company built these factory buildings starting in 1890.

**HH6. 115–19 Blatchley Avenue, St. Rose's Roman Catholic Church, 1912: Whiton & McMahon, Hartford**
The parish started in 1907, but had its first temporary building on this site in 1908. Father John J. Fitzgerald organized the construction of this Gothic Revival–style church that could seat one thousand people.

### HH7. 128 BLATCHLEY AVENUE, JOSEPH P. LAVIGNE HOUSE, 1896

This Queen Anne–style house was built for Mr. Lavigne, the manager of the Yale Motor Co.

### HH8. 183 BLATCHLEY AVENUE, GRACE EPISCOPAL CHURCH RECTORY, 1881–82

This Queen Anne–style house was built as a rectory for the Grace Episcopal Church, which until recently was located next door.

### HH9. 233–35 BLATCHLEY AVENUE, SAMUEL L. BLATCHLEY HOUSE, 1865

This French Second Empire–style house was built for and by Mr. Blatchley, head of S.L. Blatchley & Sons and one of Fair Haven's leading real estate developers in the late nineteenth century.

### HH10. 254–56 GRAND AVENUE, 1911–12

This eclectic mixed-use brick block was occupied by Mr. Still's fish market and the Princess Airdome theater.

### HH11. 219–23 GRAND AVENUE, AMERICAN BANK & TRUST COMPANY, 1915: BROWN & VON BEREN; 1925

This Beaux Arts–style bank was the most substantial in the area. In 1924, the clock was added, and the left-hand portion was added in 1925.

### HH12. 169 GRAND AVENUE, LYMAN WOODWARD HOUSE, 1851–52

This Italian Villa–style house was built for Mr. Woodward, who ran J.C Woodward grocery store on Grand Avenue.

### HH13. 155 GRAND AVENUE, GRAND AVENUE CONGREGATIONAL CHURCH, 1853: HENRY AUSTIN; 1878

Originally an Italianate-style building with a 273-foot spire, the Romanesque Revival–style front was added in 1878. The church was founded as the First Congregational Church of Fair Haven in 1830. Behind the church is the Fair Haven Cemetery, which was begun in 1808.

### HH14. 164 GRAND AVENUE, FAIR HAVEN JUNIOR HIGH SCHOOL, 1927–29: BROWN & VON BEREN

This Jacobethan Revival–style school building was built in two stages. The rear portion was built first and the front part was constructed in 1929.

### HH15. 132–34 GRAND AVENUE, ERNEST H. CRAWFORD HOUSE, 1910

This Queen Anne–style house was built for Mr. Crawford, who worked with his family's furniture and undertaking firm, the Crawford Company. The house originally sat two doors down, but it was moved here in 1929 to make room for the school.

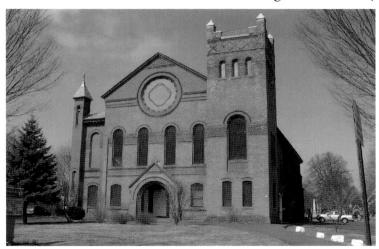

155 Grand Avenue, Grand Avenue Congregational Church, March 2007. *Photograph by Colin M. Caplan.*

### HH16. 101–05 Grand Avenue, Henry Warren Crawford Company, 1865; 1896

This French Second Empire–style building was built for the Crawford Company, furniture makers and undertakers. The rear section of the building was added in 1896.

### HH17. 93–99 Grand Avenue, Bishop Building, 1891

This Italianate-style block was built for Walter D. Bishop, an electric motor designer.

### HH18. 69 Grand Avenue, Horace H. Strong School, 1915: Brown & Von Beren

The land on this block was deeded to the people of Fair Haven in 1808 to be used for a public purpose. This Jacobethan Revival–style school was named for Henry H. Strong, organizer of one of the largest produce houses in the state.

### HH19. 98 Clinton Avenue, Thomas G. Sloan Development House, 1881–82

This Gothic Revival–style house was built by Elihu Watrous for Mr. Sloan, a real estate agent.

### HH20. 103 Clinton Avenue, Chancelor Kingsbury House, 1835

This Greek Revival–style house was built for and by Mr. Kingsbury, who developed the surrounding area.

### HH21. 118 CLINTON AVENUE, THE HOME FOR THE FRIENDLESS, 1888: HENRY AUSTIN; 1898

Begun in 1866 in a house on this site, the left wing of this building was added in 1888. In 1898, the main portion was built and named after the donor's sister, Mary Wade.

### HH22. CHATHAM SQUARE, 1911

Mimicking the Green in its form, Chatham Square was purchased by the city with the efforts of the Fair Haven Men's Club.

### HH23. CLINTON PARK, CIRCA 1850; 1890

English Mall was the first strip of open space laid out around 1850. The larger park area was a dump until 1911, when improvements were made.

### HH24. 293 CLINTON AVENUE, CLINTON AVENUE SCHOOL, 1911: BROWN & VON BEREN

This Beaux Arts–style school was built in response to the burgeoning Fair Haven population.

### HH25. 315–19 PECK STREET, A.C. GILBERT COMPANY, 1937: WESCOTT & MAPES

Alfred Carlton Gilbert intended to be a doctor when he graduated Yale Medical School, but his interest in magic changed his career, and he eventually produced the Erector Set construction toy in 1913. Gilbert was also the first man in the country to make enameled wires.

### HH26. 93–95 CLAY STREET, PETER SULLIVAN BUILDING, 1875

This Italianate-style mixed-use building was built for Mr. Sullivan, a grocer.

### HH27. 334 GRAND AVENUE, WILLIAM PORTER HOUSE, 1877

This Queen Anne–style house was built for Mr. Porter, owner of the Porter Stair Co., stair builders on East Grand Avenue.

### HH28. 338–40 GRAND AVENUE, THOMAS LOWE DOUBLE HOUSE, 1885

This Queen Anne–style double house was built for and by Mr. Lowe, a progressive carpenter and builder who helped develop a large part of the surrounding area.

### HH29. 346 GRAND AVENUE, THOMAS LOWE DEVELOPMENT HOUSE, 1885–86

This Queen Anne–style house was built by Mr. Lowe.

### HH30. 362 GRAND AVENUE, JOHN LOWE HOUSE, 1892

This Queen Anne–style house was built by Mr. Lowe, Thomas's son, who was also a carpenter and builder.

510 Grand Avenue, English Station Power Plant, September 1997. *Photograph by Colin M. Caplan.*

### HH31. 374 GRAND AVENUE, SAMUEL JOHNSON HOUSE, 1871–72
This French Second Empire–style house was built for and by Mr. Johnson, a house builder.

### HH32. 405 GRAND AVENUE, JOHN J. GIBBONS BUILDING, 1874
This Italianate-style mixed-use building was built for Mr. Gibbons, who lived upstairs and had his shoe and boot business on the ground floor.

### HH33. 458 GRAND AVENUE, STATION A RAILROAD POWER HOUSE, 1916–17: J.G. WHITE ENGINEERING CORP., NEW YORK
This Beaux Arts–style powerhouse was built for the Connecticut Company Street Railway, operators of the state's trolley system until their discontinuation in 1948. The Barnesville Bridge first bridged the Mill River at this location in 1819.

### HH34. 510 GRAND AVENUE, ENGLISH STATION POWER PLANT, 1927–29 AND 1947: WESCOTT & MAPES
The United Illuminating Company built this Gothic Revival–style monolithic powerhouse on an island made of fill. The plant was named for James English, president of the company.

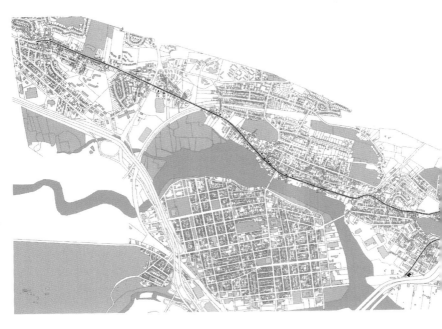

Amex, Morris Cove, Fair Haven Heights and Foxon neighborhoods driving tour map. *Compiled by Colin M. Caplan.*

Tour II.

# *Annex, Morris Cove, Fair Haven Heights and Foxon Neighborhoods*

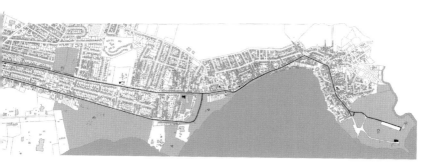

**III. 151 Forbes Avenue, Church of the Epiphany, 1904: Mantle Fielding, Philadelphia**

This Gothic Revival–style church was built as a chapel of St. Paul's Episcopal Church. It was built of East Haven brownstone to match the house next door.

153 Forbes Avenue, Jehiel Forbes House, March 2007. *Photograph by Colin M. Caplan.*

**II2. 153 Forbes Avenue, Jehiel Forbes House, 1767; 1779**

This is the only Colonial-era house built of stone existing in the city. Built for Mr. Forbes, a shipbuilder, the timber parts of the house burned when the British invaded New Haven on July 5, 1779. The house became the rectory for the Church of the Epiphany next door in 1910.

**II3. East Shore Park, 1923**

Originally a marshy area that was part of the native Quinnipiac tribe's reservation, the Park Commission acquired this land in 1923. Dredge from the harbor was used to fill the swamps in 1941, which called for the planting of pampas grasses to ease erosion.

**II4. Fort Nathan Hale park, 1890; 1921**

On this site were built Black Rock Fort in 1776 and then Fort Nathan Hale around 1805, which halted the British from attacking during the War of 1812. The camouflaged concrete bunkers and earthen mounds were constructed in 1863, while Fort Hale was reconstructed in 1976. The Park Commission acquired the park in 1890 and the fort in 1921.

**II5. 341 Townsend Avenue, Jacob Pardee House, circa 1752**

This Colonial-era house is now hidden behind twentieth-century houses.

**II6. 324 Townsend Avenue, Abijah Pardee–Forbes House, 1774**

This Colonial-era house was built using timber brought over on schooners from Long Island. The bluff it sits on was called Belsar's Hill.

**II7. 305 Townsend Avenue, circa 1900**

The view is spectacular from this Swiss Chalet– and Gothic Revival–style cottage.

## II8. 265 TOWNSEND AVENUE, CAPTAIN CHANDLER PARDEE HOUSE, CIRCA 1810 OR 1800–10

This Federal-era house was moved south and made into a guesthouse called the Pioneer by Captain Samuel C. Thompson.

View of Morris Cove from the Palisades, circa 1890. *Courtesy of Joseph Taylor.*

## II9. 325 LIGHTHOUSE ROAD, PARDEE-MORRIS HOUSE, CIRCA 1680; 1767; 1779; CIRCA 1920

The oldest existing house in the city, since 1918 this stone ender has been owned by the local historical society as a museum. The house was built by Thomas Morris around 1680. In 1767, the large ell was added and on July 5, 1779, the house was burned by British. It was later rebuilt using existing stone and timbers.

325 Lighthouse Road, Pardee-Morris House, circa 1905. *Courtesy of Joseph Taylor.*

## II10. LIGHTHOUSE POINT PARK, 1924

Acquired by the Park Commission in 1924, this site was used by the Quinnipiac to collect shellfish, which resulted in a giant mound of dispensed shells. The octagonal lighthouse was built in 1840 and was used until 1877. The carousel building dates to 1916.

Lighthouse Point Park, circa 1948. *Photograph by Alvina Morgan. Courtesy of Colin M. Caplan.*

## II11. 480 TOWNSEND AVENUE, NATHAN HALE SCHOOL, 1923: BROWN & VON BEREN

This Tudor Revival-style school was named for Nathan Hale, a Revolutionary War Patriot spy from Coventry who was made famous for saying, "I only regret that I have but one life to lose for my country," just before he was executed.

709 Townsend Avenue, Bayridge, circa 1865. *Courtesy of Joseph Taylor.*

## II12. 709 Townsend Avenue, Raynham, 1804; 1856

This house was originally built by Kneeland Townsend, a prosperous merchant whose family had owned this estate since they purchased the land from the Quinnipiac. In 1856, the house was remodeled in the Gothic Revival style.

## II13. Fort Wooster Park, 1890

The Park Commission acquired this site in 1890, which was named Grave Hill by the Puritans because the Quinnipiac had a burial ground on the eastern slope. The area was also known as Beacon Hill after smoke signals were used here during the Revolutionary War. It was named Fort Wooster in 1812.

## II14. 1138 Townsend Avenue, John Woodward Jr. House, circa 1741 or circa 1743

This large Colonial-era house was shelled by the British when they attacked New Haven in 1779. A cannon shell is said to have been lodged in the gable. The area was called Woodwardtown by 1860, due to this family's settlement here.

## II15. 458 Forbes Avenue, St. Andrews Methodist Church, 1892

This Gothic Revival–style church marked an important intersection called the Four Corners.

## II16. 490 Quinnipiac Avenue, Jessie Mallory House, circa 1810

This Federal-era house, the oldest known house in the vicinity, was built for Mr. Mallory on land he purchased from East Haven.

## II17. 603 Quinnipiac Avenue, Luzerne Ludington House, 1883

This Queen Anne–style house was built for Mr. Ludington, who worked with his family's business, C.L. Ludington & Sons, oyster growers.

## II18. 624–28 Quinnipiac Avenue, Justin Kimberly House, 1828–29

This early nineteenth–century vernacular–style house was built for Mr. Kimberly, a blacksmith.

## II19. 627 Quinnipiac Avenue, Obadiah Dickerman House, circa 1840

This Italian Villa–style house, on the rise overlooking the river, was built for Mr. Dickerman.

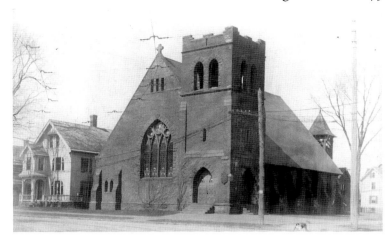

458 Forbes Avenue, St. Andrews Methodist Church, circa 1910. *Courtesy of Joseph Taylor.*

**II20. 640–42 QUINNIPIAC AVENUE, JOSEPH AMES JR. HOUSE, 1831**
This Italianate-style double house was built for Mr. Ames, an oyster harvester.

**II21. 701 QUINNIPIAC AVENUE, EDWIN D. FOWLER HOUSE, 1845**
This Greek Revival–style house was built for Mr. Fowler, a jeweler on East Grand Avenue.

**II22. 705 QUINNIPIAC AVENUE, WILLIAM AND LOIS BRADLEY HOUSE, 1835**
This Greek Revival–style building was built for Mr. Bradley on farm land he purchased from Isaac Brown.

**II23. 715 QUINNIPIAC AVENUE, SAMUEL MILES BROWN HOUSE, 1765; 1856**
This house was originally a Colonial-style house. It was remodeled in the Italianate style in 1856 when it became home to Mr. Brown, who operated a grocery store on the corner of East Grand Avenue.

**II24. 731AND 735 QUINNIPIAC AVENUE, H. & R. ROWE HOUSES, CIRCA 1830**
These matching robust Greek Revival–style houses were built for the Rowes, who were involved in their family's oyster harvesting business.

**II25. 759 QUINNIPIAC AVENUE, WILLIS HEMMINGWAY HOUSE, 1849**
This Italian Villa–style house was built for Mr. Hemmingway, father of Samuel from East Pearl Street (see S26), and head of a popular dry goods store on East Grand Avenue.

**1126. 818 QUINNIPIAC AVENUE, HENRY MALLORY HOUSE, 1845–51**
This Italian Villa–style house was built for Mr. Mallory, an oyster harvester.

**1127. 965 QUINNIPIAC AVENUE, CIRCA 1880**
This large Stick-style house was occupied by Charles E. Bray, a stove dealer on East Grand Avenue.

**1128. 1190 QUINNIPIAC AVENUE, ANDREW BARNES HOUSE, CIRCA 1855**
This Italianate-style house was built for Mr. Barnes, a partner in Strong, Barnes & Hart Co., the oldest and largest wholesale meat dealer in the city.

**1129. 1212 QUINNIPIAC AVENUE, HERBERT BARNES HOUSE, 1870**
This Gothic Revival–style house was built for Mr. Barnes, a partner in the Strong, Barnes & Hart Co., the oldest and largest wholesale meat dealer in the city, begun in 1854. The company became Sperry & Barnes in 1870.

**1130. 1659 QUINNIPIAC AVENUE, PHILEMON AND SARAH HARRISON HOUSE, 1788**
This Colonial-era house was built by Mr. Harrison four years after he was married.

**1131. 1670 QUINNIPIAC AVENUE, SAMUEL HEMMINGWAY HOUSE, 1771–81**
This area was called Hemingwayville after the family who populated this area. Mr. Hemingway built this Colonial-era house after his son moved into his old home nearby.

**1132. 1706 QUINNIPIAC AVENUE, WIDOW SMITH HOUSE, CIRCA 1760**
This Colonial-era house was built by Samuel Hemmingway. Mr. Hemmingway's son, Samuel Jr., ran a tavern and hotel here. The house is named for Sybil Smith, who acquired the house from her father in 1822.

# Bibliography

Beardsley, Reverend William A. *History of Saint Thomas Church*. New Haven: Tuttle, Morehouse & Taylor Co., 1941.

Brown, Elizabeth Mills. *New Haven: A Guide to Architecture & Urban Design*. New Haven: Yale University Press, 1976.

Brown & Von Beren. *Architecture: A Few Types of Homes and Other Buildings Exemplifying the Tendency of Modern Architecture*. New Haven: Tuttle, Morehouse & Taylor Co., 1906.

Cannelli, Antonio. *La Colonia Italiana di New Haven*. New Haven: Antonio Cannelli, 1921.

Citizens Park Council of Greater New Haven. *New Haven Outdoors, a Guide to the City's Parks*. New Haven: Field Graphics Inc., 1990.

City of New Haven. *Inside New Haven's Neighborhoods, a Guide to the City of New Haven*. New Haven: George E. Platt Co., 1982.

*Commercial Record*. New Haven: The Record Publishing Co., 1898–1932.

Dana, James D. *On the Four Rocks of the New Haven Region*. New Haven: Tuttle, Morehouse & Taylor Co., 1891.

Dana Collection, New Haven Museum and Historical Society.

Elliot, S.H. *The Attractions of New Haven: A Guide to the City*. New York: N. Tibbals & Co., 1869.

Hasse, William, Jr. *A History of Banking in New Haven, Connecticut*. New Haven: Whaples-Bullis Co. Inc., 1946.

Hayward, Marjorie F. *The East Side of New Haven Harbor*. New Haven: New Haven Colony Historical Society, Yale University Press, 1938.

Herman, Barry E. *Jews in New Haven Volume II*. Hamden, CT: Abbott Printing Co., 1979.

Herman, Barry E., and Werner S. Hirsch. *Jews in New Haven Volume III*. Hamden, CT: Abbott Printing Co., 1981.

Hirsch, Werner S., and Renee Kra. *Jews in New Haven Volume V*. Hamden, CT: Abbott Printing Co., 1988.

Historic American Buildings Survey. *New Haven Architecture*. Washington, D.C.: Division of Historic Architecture, Office of Archaeology and Historic Preservation, National Park Service, 1970.

Holden, Reuben A. *Yale: A Pictorial History*. New Haven: Yale University Press, 1967.

Hook, James W. *The Geometric Tool Co.* New Haven: The Geometric Tool Co., 1943.

Hornstein, Harold, John O.C. McCrillis and Richard Hegel. *New Haven Celebrates the Bicentennial.* New Haven: Eastern Press Inc., 1976.

Lattanzi, Dr. Robert M. *Oyster Village to Melting Pot: The Hill Section of New Haven.* Chester, CT: Pattaconk Brook Publications, 2000.

Leeney, Robert J. *Elms, Arms and Ivy: New Haven in the Twentieth Century.* Montgomery, AL: Community Communications, Inc., 2000.

Lyman, Dean B., Jr. *An Atlas of Old New Haven.* New Haven: Charles W. Scranton & Co., 1929.

Maynard, Preston, Marjorie B. Noyes, eds., Sylvia M. Garfield and Carolyn C. Cooper, associate eds. *Carriages and Clocks, Corsets and Locks: The Rise and Fall of an Industrial City—New Haven, Connecticut.* London: University Press of New England, 2004.

McAleter, Virginia, and Lee McAleter. *A Field Guide to American Houses.* New York: Alfred A. Knopf, Inc., 1984.

McCluskey, Dorothy S., and Claire Bennitt. *Who Wants to Buy a Water Company? From Private to Public Control in New Haven.* Bethel, CT: Rutledge Books, Inc., 1996.

Mitchell, Mary Hewitt. *History of The United Church of New Haven.* Lancaster, PA: Lancaster Press, 1942.

Murphy, Wendy. *A Leader of Substance Yale-New Haven Hospital at 175 Years.* Lyme, CT: Greenwich Publishing Group, Inc., 2001.

*New Haven Directory.* New Haven: Price & Lee Co. & J.H. Benham, 1840–1952.

Philip, Arthur V. *History of the Department of Police Service.* New Haven: Arthur V. Philip, 1906.

Rae, Douglas W. *City: Urbanism and its End.* New Haven: Yale University Press, 2003.

Sarna, Jonathan D. *Jews in New Haven.* West Haven, CT: Kramer Printing Co., 1990.

Shumway, Floyd, and Richard Hegel. *New Haven: An Illustrated History.* Woodland Hills, CA: Windsor Publications, 1987.

Starr, Harris Elwood. *Second Company Governor's Foot Guard Souvenir History.* New Haven: M.H. Davidson Co., 1950.

Stoddard, Paul W. *Sixty Years: A History of Summerfield Methodist Episcopal Church.* New Haven: Summerfield Methodist Episcopal Church, 1931.

Townshend, Doris B. *Fair Haven: A Journey Through Time.* New Haven: Eastern Press, 1978.

————. *The Streets of New Haven: The Origin of their Names.* New Haven: New Haven Colony Historical Society, 1984.

Warner, Robert Austin. *New Haven Negroes: A Social History.* New Haven: Yale University Press, 1940.

# Index